Decorating with Concrete
Outdoors

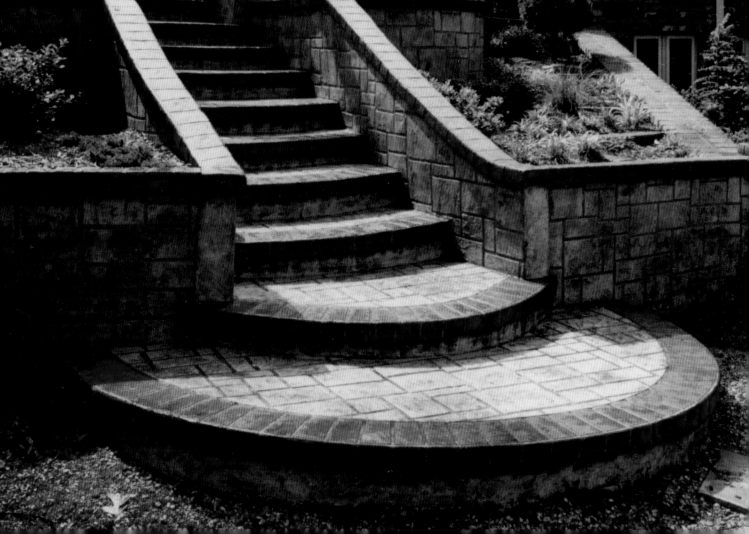

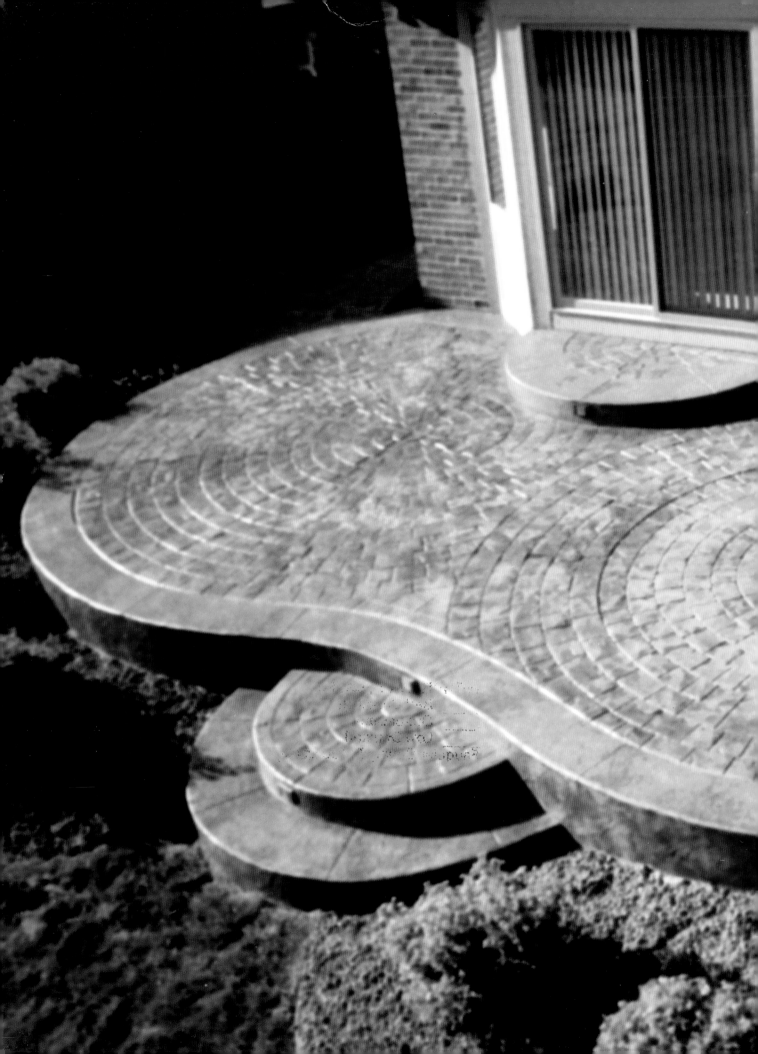

Decorating with Concrete
Outdoors

Driveways, Paths & Patios, Pool Decks & More

Schiffer Publishing Ltd ®

4880 Lower Valley Road, Atglen, PA 19310 USA

Tina Skinner
The Concrete Network

1000359231

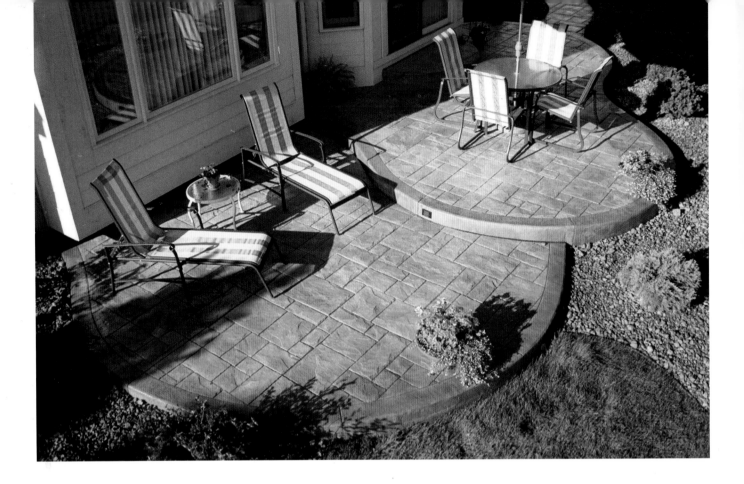

Library of Congress Cataloging-in-Publication Data:

Skinner, Tina.
 Decorating with concrete outdoors : driveways, paths & patios,
pool decks & more / by Tina Skinner & The Concrete Network.
 p. cm.
 ISBN 0-7643-2199-4 (pbk.)
1. Concrete construction. 2. Outdoor living spaces. 3. Landscape
architecture. I. Concrete Network. II. Title.

NA7160.S48 2005
721'.0445—dc22

 2005000100

Designed by John P. Cheek
Cover Design by Bruce Waters
Type set in Stone Sans/Humanist 521 BT

ISBN: 0-7643-2199-4
Printed in China

Photo Credits:
Cover images courtesy of Classic Concrete and Michelle Carpentier,
Engrave-A-Crete™, *and Sonoma Cast Stone.*

Published by Schiffer Publishing Ltd.
4880 Lower Valley Road
Atglen, PA 19310
Phone: (610) 593-1777; Fax: (610) 593-2002
E-mail: Info@schifferbooks.com

For the largest selection of fine reference books on this and
related subjects, please visit our web site at
www.schifferbooks.com
We are always looking for people to write books on new and
related subjects. If you have an idea for a book please contact
us at the above address.

This book may be purchased from the publisher.
Include $3.95 for shipping.
Please try your bookstore first.
You may write for a free catalog.

In Europe, Schiffer books are distributed by
Bushwood Books
6 Marksbury Ave.
Kew Gardens
Surrey TW9 4JF England
Phone: 44 (0) 20 8392-8585; Fax: 44 (0) 20 8392-9876
E-mail: info@bushwoodbooks.co.uk
Free postage in the U.K., Europe; air mail at cost.

Contents

Acknowledgments

The momentum for this book was made possible by The Concrete Network. Streamlined by the quick decision-making ability of founder Jim Peterson, and aided by the efficient staff, including Khara Betz, we quickly contacted all the members of this amazing website to find the talent for this publication. To those who contributed, special thanks for your amazing submissions, and kudos for your craft. It was this pride in craftsmanship and technology that inspired this publication in the first place. Also, thanks to Nathaniel Wolfgang-Price and Ginny Parfitt, who helped sort images and create captions. Also, many thanks to Michelle Carpentier, Lisa Thomas, and Matthew Gregorchuk, who helped illuminate the works herein with their artful eye and lenses. These photographers are always in search of new commissions. Please consider them:

Michelle Carpentier, The Photography Shoppe
South Richfield, Minnesota
612-869-0691
www.photographyshoppe.com

Lisa Thomas
San Mateo, California
650-222-4338
lisamtms@sbcglobal.net

Matthew Gregorchuk Photography
The440@hotmail.com
805-667-2254

Introduction

As you peruse this book, you'll see that concrete is now being used in a way that many people haven't thought of before. The decorative concrete industry is exploding with options for walkways, pool decks, patios, and driveways, and lots of folks are asking, why?

So, why is decorative concrete becoming so popular?

In this day and age (it's tough out in the world) people want their own home oasis, a place to get away from it all and cocoon with the family. Decorative concrete allows one to have beautiful surfaces outside – just like a resort.

Concrete is less expensive, in most cases, than stone, marble, or pavers, so it makes these beautiful surfaces more possible from a financial point of view.

Decorative concrete is a craft product; working directly with a craftsman to design a one-of-a-kind product is appealing to many people.

There have been broad improvements in the number and type of decorative concrete products – microtoppings, overlays, stamps, colors, acid stains, dyes, water based stains, epoxy terrazzo, etc.

These products have expanded the tool kit of well established concrete contractors and have drawn creative folks into the concrete industry that now like to use concrete as their canvas – and are helping to take creativity with the concrete medium to a new level.

Finally, all of the above listed items are working together to take decorative concrete to the "tipping point." As more people see it and learn about it, more people want it.

When you see, in this book, the options available to you for your own "resort" right at home, I think you are going to want it too!

Jim Peterson
President and Founder
The Concrete Network

Why Concrete?

As homeowners are discovering, there are three good reasons:

Versatility

Concrete surfaces outdoors are unlike any other type of surface. An endless variety of looks is available with concrete. It can be shaped into any pattern, lightly smoothed or heavily brushed, surfaced with attractive pebbles, swirled or scored, tinted or painted, patterned or molded to resemble other materials.

Durability

Concrete can stand up to the entire range of weather conditions, from Florida to Canada, when installers take appropriate measures to ensure its durability. In the cold climate conditions of the north, a lot of steel and rebar, and two-foot grid patterns are essential to stand up to the freezing and thawing cycles that can cause cracking, says Mike Verlennich of Verlennich Masonry and Concrete in Minnesota.

Whereas traditional pavers and cobblestones may settle unevenly during the freeze/thaw cycle, reinforced stamped concrete has the necessary tensile strength to resist the constant heaving caused by weather changes.

Affordability

Those wonderful, expensive looks you've always coveted – stone, tile, slate, are all available in concrete. New technology, lots of new product, and a growing workforce of trained craftsmen make decorative concrete available to most homeowners. The wide array of patterns and colors available make it possible to substitute concrete for almost any hardscaping material, from flat to vertical finishes, at a fraction of the cost. Concrete can cost up to one-third of stone, brick, or tile installations. Brick, slate, flagstone, stone, tile, and even wood can be precisely mimicked in concrete.

Is it any wonder that it is growing in popularity?

One of the biggest draws for concrete hardscaping is the expansive range of colors available. Because of ever-advancing technology and jaw-dropping chemical techniques, concrete can be colored in just about any hue you could ever imagine. Some contractors offer upwards of 250 hues and shades.

Colored concrete can be used in combination, abutting each other, or stamped with a variety of textures to simulate brick, flagstone, pavers, or tile.

The same colored concrete can be made to look different, just by using different finishing techniques. For example, a broom finish creates one look. Brooming the concrete in opposite directions creates shadow effects. Swirl or fan patterns create a different type of look. For even more dramatic effect, the colored concrete can be lightly or heavily sandblasted, or a retarder can be used and then the aggregate exposed. Color can be integrated into the concrete mix, or dusted onto the wet surface of concrete. Wet stains can be applied to set concrete, painted on using techniques as sophisticated as the artist, or craftsman, can master.

Color technology often improves the durability of concrete. Coloring agents can actually harden the concrete surface, and curing compounds in matching colors cure, seal, harden, and dustproof concrete surfaces.

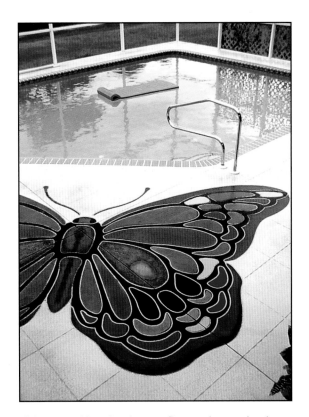

▲ Images like this butterfly can be etched onto a pre-existing concrete surface. *Courtesy of Engrave-A-Crete*™

Acid Stains >

Whereas staining concrete used to be treated as a last resort for improving the appearance of an inexpensive concrete slab, today's homeowners are going out of their way to create concrete surfaces in order to have them stained. Concrete staining is gaining in popularity by the minute. Some of the work craftsman are doing with stains is truly fabulous. Stain colors span the hues of the rainbow, and the possibilities are as wide open in concrete décor as a blank canvas in an artist's studio.

It's no longer the cheap fix of last resort, though. The price of stained floors can rival the cost of ceramic tile. This is because the procedure tends to be very labor intensive. Acid stains are painted on, often in multiple coats to achieve shadowing and variegated looks. And perfect edges are created by hand-routing the lines, and grouting them after the stains have been applied.

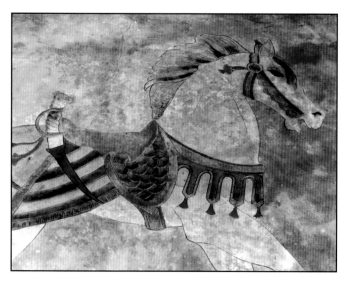

▲ This carousal horse was created by Gerald Taylor of Images in Concrete. Created on a 10' x 10' concrete "canvas," it was fashioned with a diamond-bit angle grinder and special concrete stains. The image was based on one found in a book called *Carousel Animals* by Christy Shaffer. *Courtesy of Images in Concrete*

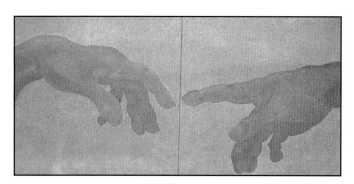

◄ A more stylized take on the Michelangelo original, Gerald Taylor's "Hand of God" was commissioned by Southern Arkansas University and is just outside the entrance to the Brinson Fine Art Building. Both hands point to a sawn seam in the concrete, a necessity of any concrete slab. The seam will direct the inevitable cracking, keeping it away from more crucial areas of the platform. After artist Steven Ochs created the outline in charcoal, Gerald Taylor cut the lines freehand using an angle grinder with a 4" diamond blade to a depth of approximately 1/8" to 1/4" deep. A red acid stain was used, and then lightened by Ochs, who used a carbide rubbing brick to create highlights. A non-film forming sealer protects the image. *Courtesy of Images in Concrete*

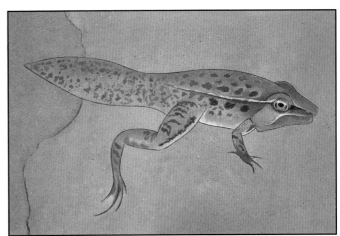
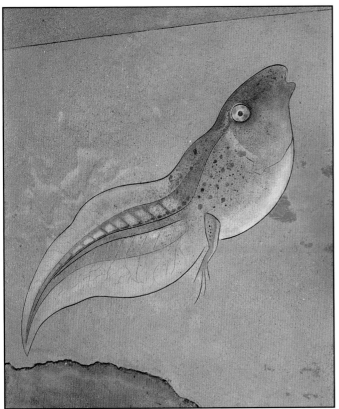
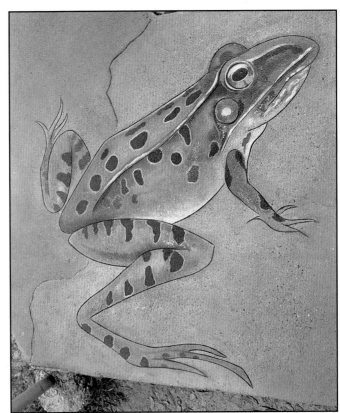

▶Four images along an elementary school walkway trace the stages from egg to frog. Funded by Project Wild, a schoolyard habitat grant from the Arkansas Game and Fish Commission, the project was executed in Emerson, Arkansas, by Steven Ochs, an Art Professor at Southern Arkansas University, and Gerald Taylor of Images in Concrete. An angle grinder defined the color areas, which were stained using acrylic and acid stains, and then the lines were accented with black and the whole sealed for many years of heavy wear and tear. *Courtesy of Images in Concrete*

Stamped Concrete >

Techniques used for stamping concrete were developed in the 1960s. Then, stamping tools were made of metal and resembled cookie cutters. They were able to produce a pattern, but did not provide any texture. Today's tools are rigid mats made of polyurethane that produce authentic textured patterns of stone, brick, and even wood planking and fossilized sea-life.

A wonderful advantage of stamped patterns over the actual surfaces they imitate is that the craftsman can get the same effect with less relief. In other words, a cobblestone look-alike is actually smoother, and safer to walk on. And tables and chairs don't wobble on a stamped surface.

It's also easier to select from a huge palette of available colors for concrete than to go out to a stone or brick yard and select hues that coordinate with the architecture or existing natural elements in your landscape.

Different stamped patterns are more popular in various regions. For instance, homeowners in the South tend to favor ashlar slate, grand ashlar slate, royal slate, European fan, and London cobblestone patterns. In the Midwest, flagstone and Roman ashlar slate patterns seem more popular, while up north the granite and flagstone textures are more popular, as well as stone that is natural to the area. On the West Coast, ashlar slate tends to find favor.

Stamping techniques are used to create brick, slate, flagstone, stone, tile, and even wood. Though used for many years in commercial applications, the technique is becoming increasingly popular in residential applications.

Colors and patterns for stamped concrete are often chosen to blend with other stone or tile elements at the residence. Complex designs incorporating steps, courtyards, and fountains can be achieved. Stamped concrete can also be blended with other decorative concrete elements such as exposed aggregate finishes and acid-etch staining. Many offer dozens of patterns.

The more common stamped patterns include ashlar slate, cobblestone, weathered wood, European fan, herringbone, and Roman slate, clay, and granite tiles.

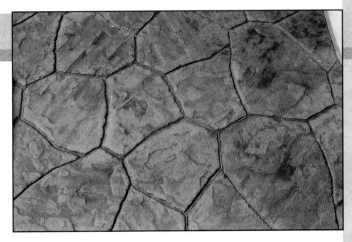

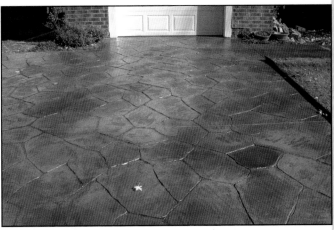

Here concrete has been stamped and colored in order to resemble sandstone. *Courtesy of Ministry Concrete*

Stamped and stained concrete imitates random stone on a drive and entryway. *Courtesy of Concrete Creations*

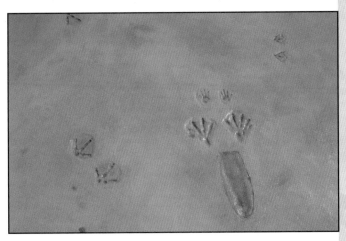

Cleverly created using stencils, it appears a duck and raccoon passed over before this primordial mud had set. *Courtesy of Concrete Creations*

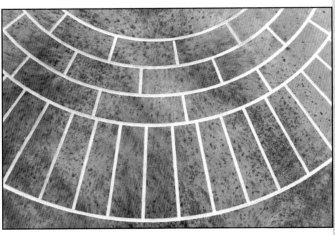

Broad stenciled lines mimic grouting on a stained concrete floor. *Courtesy of Engrave-A-Crete™*

Stenciling >

Stenciling is another technique for providing fantastic looks in concrete. Done at the time the concrete is poured, stenciled concrete can give your hardscape many different patterns, in almost any color and/or texture imaginable.

The primary advantage of stenciling is that a high quality finish and image can be achieved at a very reasonable price and in a relatively short period of time. At the time a new area of concrete is poured, a stencil is laid on the wet concrete and a color hardener is spread and troweled in so that when the stencil is removed, a "grouted" pattern is achieved. In other words, using a brick stencil, a craftsman might apply a variety of red hues to the surface. When the stencil is removed, white lines will create the appearance of mortar or grouting between the bricks.

The surface can also be textured by using rollers that simulate the uneven surfaces of stone, or the porous surface of brick. Decorative features, edging, special designs, monograms, family crests, company logos – all can be created using stencils.

After stenciling, the area is washed and sealed for permanent effect.

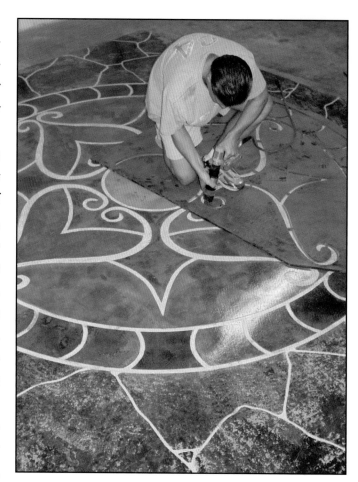

▲White lines are sandblasted through a stencil to create the finishing touches of this stained concrete design. *Courtesy of Engrave-A-Crete*™

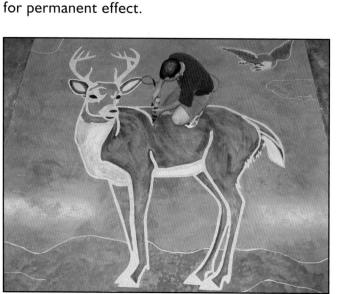

◄Using templates and stencils, a detailed picture like this deer can be etched into concrete. The craftsman uses a concrete engraver to engrave the final white lines. *Courtesy of Engrave-A-Crete*™

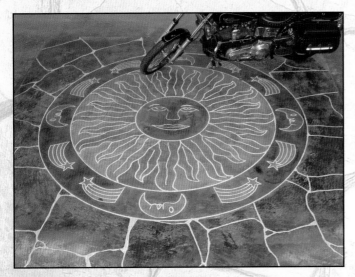

A sunburst surrounded by crescent moons and shooting stars decorates a parking deck. *Courtesy of Engrave-A-Crete™*

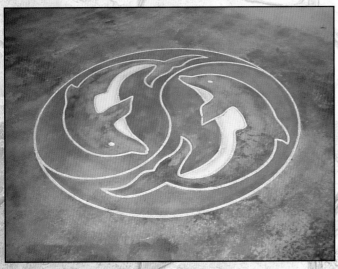

Two dolphins endlessly pursue each other in a Ying-Yang circle. *Courtesy of Engrave-A-Crete™*

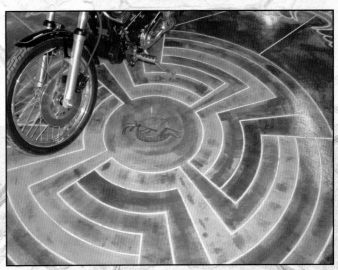

Two stenciled works feature Kokopelli, the humpback flute player whose image is seen in Native American Artwork. *Courtesy of Engrave-A-Crete™*

Pavers

Another concrete product that is increasing in popularity is pavers. Unlike poured concrete, pavers are reusable, and can be lifted and replaced when underground wiring or plumbing needs servicing, or if settling requires filling or fixing.

Pavers can be manufactured using molding techniques and colors to imitate stone and clay brick, as well as a wonderful array of interlocking shapes. Because of the increasing array of styles to choose from, the popularity of concrete pavers for residential construction projects is soaring.

Resurfacing

If you have an existing patio, walkway, or drive that needs some sprucing up, resurfacing is a great alternative. Some companies install resin-modified cementious concrete coatings systems that simulate brick, stone, tile, slate, and epoxy floors. Textured and colored overlays can be applied over just about any surface, but they are only as good as the concrete surface beneath. If the base isn't solid, the overlay won't adhere properly.

The process typically involves three steps:

First the surface is prepared to ensure permanent bonding of the coating to the existing concrete. Any existing cracks will be filed, and the surface will be thoroughly scoured.

Next the concrete coating is applied. This usually involves high-quality polymer modified cements, epoxy material, and/or coatings, which are hand-troweled 1/8- to 1/4-inch thick and then color tinted. Other coatings can be spray-applied using a compressor and hopper gun-type sprayer, and then knocked down flat using a trowel to create the texture or finish desired. Finishing sprays can then be applied in any color desired.

The final step involves applying a topcoat to provide extra stain resistance and to help keep the surface looking like new. Additional embellishment such as decorative borders can be applied using tape or stencils to enhance the appearance of the trowel knockdown application. The sealer coat will lock in lasting beauty.

Maintenance

Concrete maintenance is a breeze. Cleaning and sealing stamped and colored concrete should be done on a regular basis, just like any form of home maintenance. The frequency will depend on the amount of traffic the concrete endures, as well as weather conditions, and whether the surface is exposed to any chemicals.

Your local contractor or product manufacturer should be consulted for maintenance tips in your area.

Distinctive Concrete recommends that its New England customers reseal their concrete surfaces every two to three years. The process is as follows:

Clean the surface by rinsing dirt and debris away with a garden hose or pressure washer. Apply a small amount of liquid dish soap to the surface and scrub with a push broom. Rinse the surface well, continuing until there is no sign of soapsuds. Dry the surface completely using a leaf blower or by waiting twenty-four hours for the surface to airdry.

Stir one jar of anti-skid material into a five-gallon pail of sealer. Apply the sealer using a 1-inch nap roller only. Anti-skid material will not transfer through a sprayer. Apply in sections approximately 2' x 4' to ensure full coverage without missing spots. Keep stirring the sealer as you apply to keep the anti-skid suspended.

The sealer should be applied when the air temperature is above 55 degrees. The best results will be obtained if you apply in fall and spring, when the temperatures are cooler, or before 10 A.M. and after 4 P.M. in the summer months, when surface temperatures are under 90 degrees.

A second coat can be applied after the first coat is tack free, not sticky to touch.

Vertical Applications

When most people think of using concrete to improve the exterior appearance of their home, they think of ground level applications. But today's technology allows for vertical applications, too. Thin veneers of concrete can be applied to almost any surface and textured to create many different appearances. So having that field-stone house no longer involves stacking when concrete is put to use. Special stamps create the texture, and pigment can be applied to mimic any desirable surface for an exterior wall, or even a retaining wall or existing set of steps.

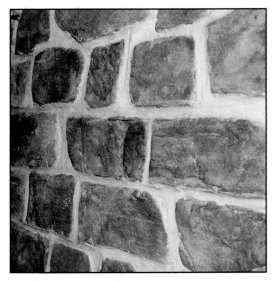

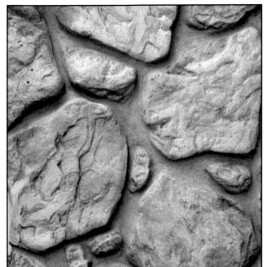

◀ Four close-up shots illustrate the intricate detailing that could convince anyone that these walls were crafted from stacked stone. In fact, all are faux-finished concrete. *Courtesy of Yoder & Sons LLC*

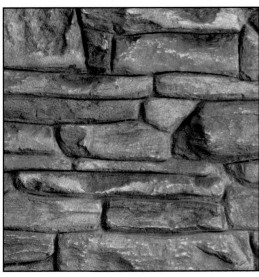

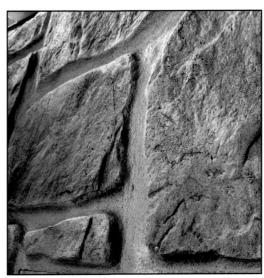

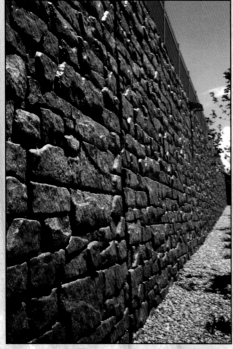

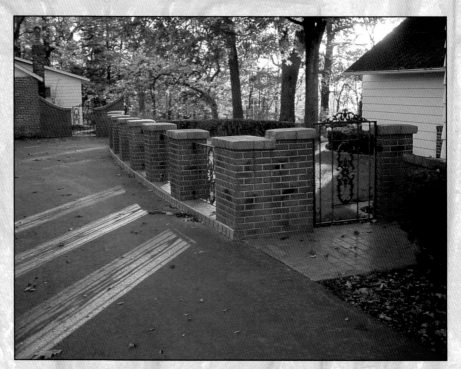

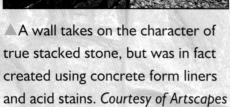A wall takes on the character of true stacked stone, but was in fact created using concrete form liners and acid stains. *Courtesy of Artscapes*

The pillars of this surround and the walkway emulate brick and add an appealing touch of formality. *Courtesy of DCI*

Retaining walls got a facelift with the vertical application of concrete that was painstakingly stenciled and textured to mimic real stone and brick. *Courtesy of DCI*

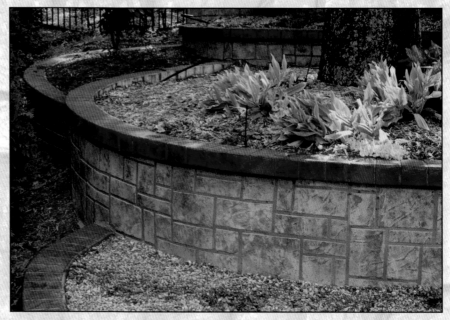

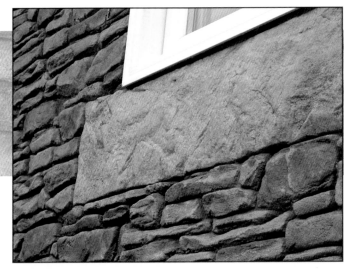

◀▼A stacked fieldstone pattern makes this house look like an Old World estate. *Courtesy of Yoder & Sons LLC*

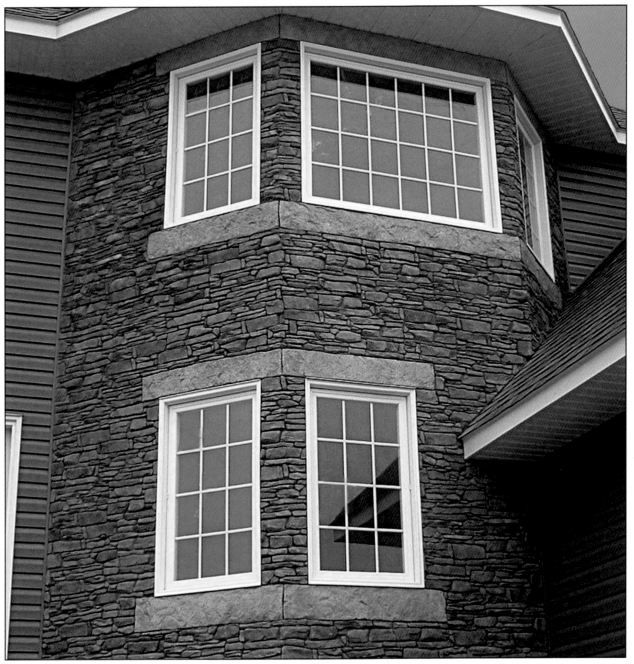

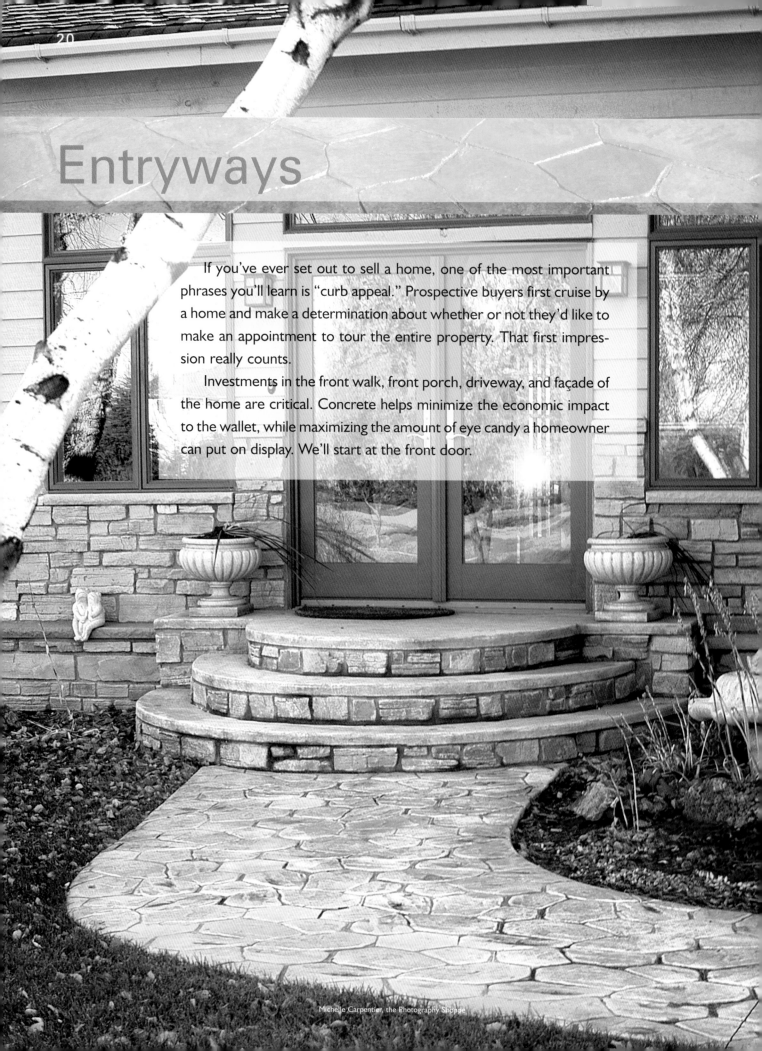

Entryways

If you've ever set out to sell a home, one of the most important phrases you'll learn is "curb appeal." Prospective buyers first cruise by a home and make a determination about whether or not they'd like to make an appointment to tour the entire property. That first impression really counts.

Investments in the front walk, front porch, driveway, and façade of the home are critical. Concrete helps minimize the economic impact to the wallet, while maximizing the amount of eye candy a homeowner can put on display. We'll start at the front door.

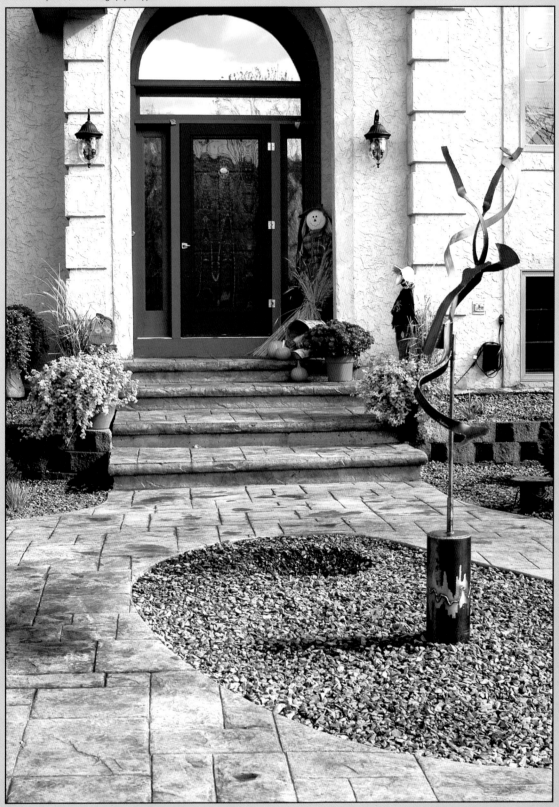

▲The classic stone texture and light gray color augment the formality of the entranceway.

◀The curved walkway and rounded entrance steps echo the shapely transoms of the façade. *Courtesy of Classic Concrete*

Photography by Matthew Gregorchuck

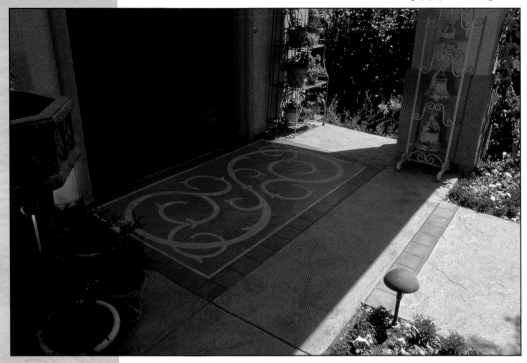

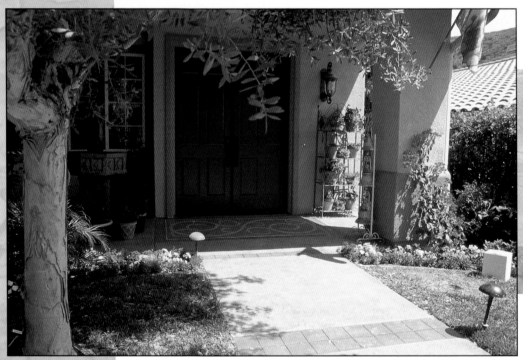

▲Concrete has been etched into a swirling vine pattern to create an interesting looking, and permanent, welcome mat. *Courtesy of Concrete-FX*

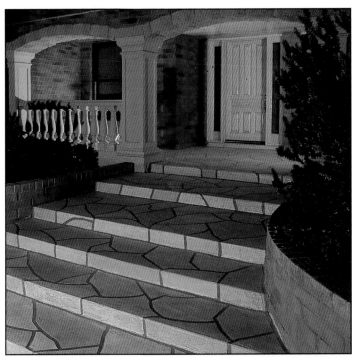

◀The cracks of this flagstone pattern wrap the fronts of the steps, giving the impression that actual flagstones were stacked for this entryway. *Courtesy of XcelDeck™*

▼Concrete facings can mimic stone and make a newer house look a little older and give it a bit of class. *Courtesy of Yoder & Sons*

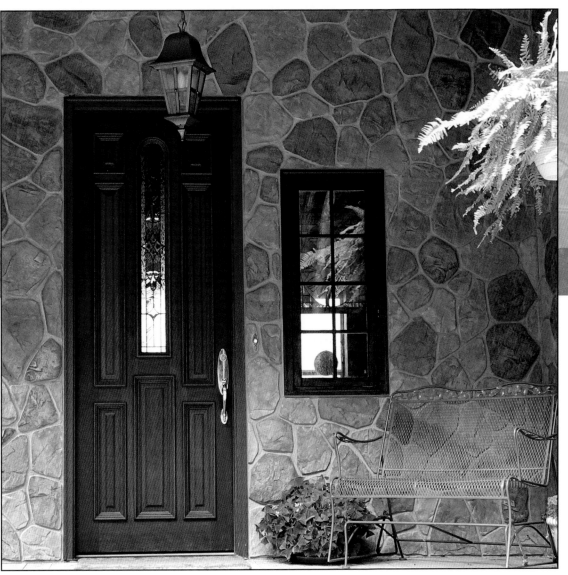

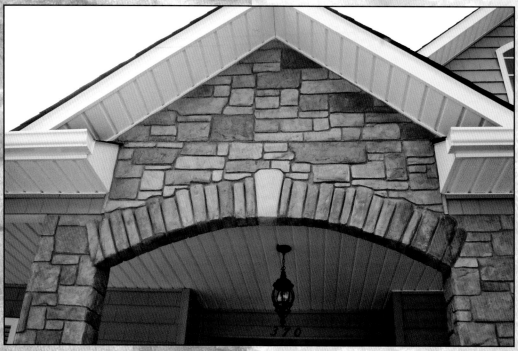

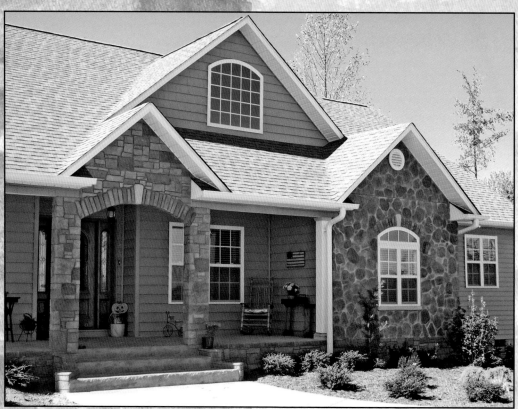

Concrete facings make a suburban house look more sophisticated. *Courtesy of Yoder & Sons LLC*

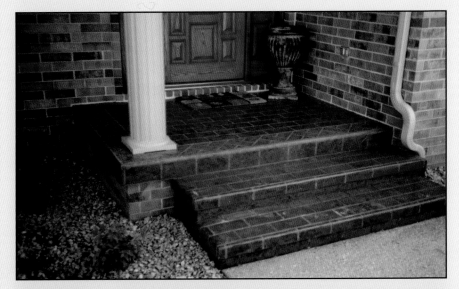

By mimicking tile and brick, a concrete sculptor can smooth and round edges. Don't be fooled, the concrete isn't simply seen here on the walking surfaces, it also was used to create the "brick" walls! *Courtesy of DCI*

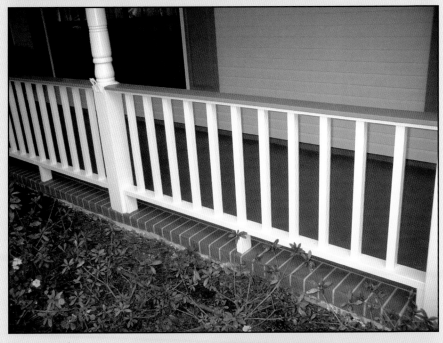

A front porch gains a faux-brick border in this artful job. *Courtesy of Specialty Concrete Designs*

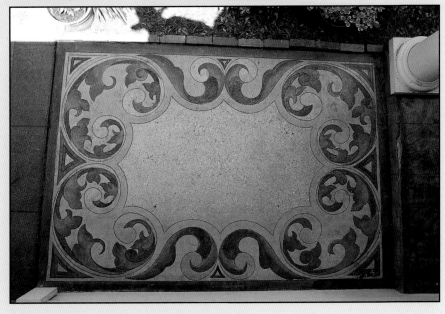

The decorative scrolls in this "entrance mat" announce that you have indeed, arrived. *Courtesy of Images in Concrete*

▶A stylized concrete entry pad comple-
ments the Art Deco architecture beyond .
Courtesy of Images in Concrete

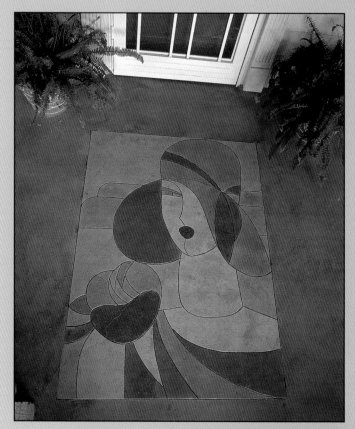

▼The faux stone finish of the porch and walkway
were carefully color coordinated to match a planter
bed border of pre-cast block. *Courtesy of DCI*

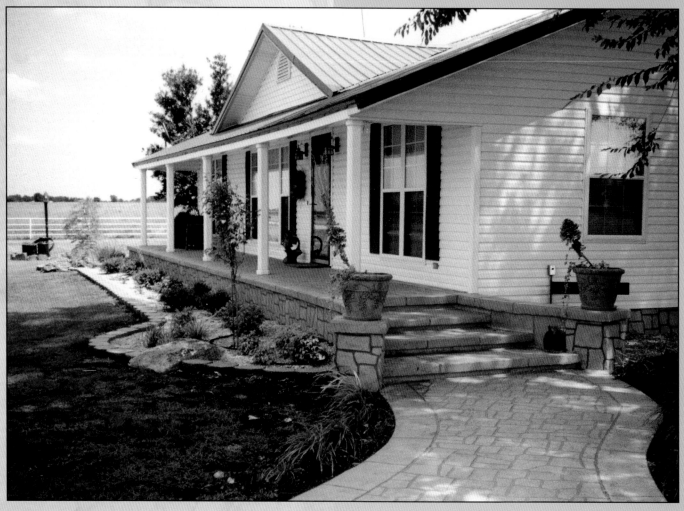

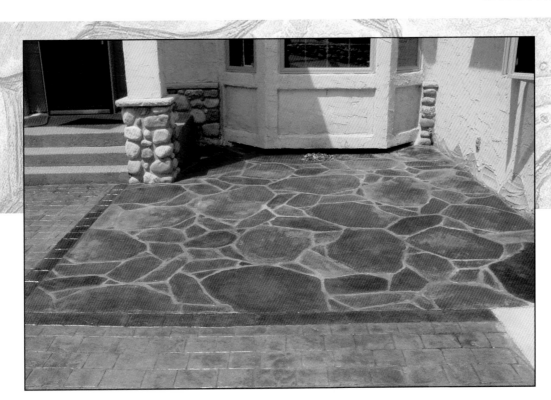

▲A quiet corner is eked out of the brick-patterned entry patio and is defined by complementary colors and contrasting shapes. Careful hand coloring ensured the effect of individual stones, and custom brick border for this expanse of concrete. *Courtesy of Verlennich Masonry & Concrete*

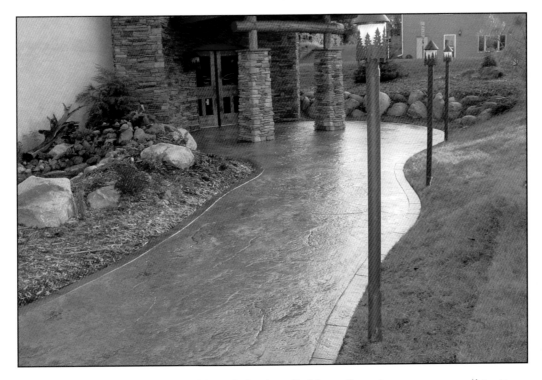

▲Like a lazy stream, this highly polished walk "flows" to the entrance and invites you to meander along and enjoy the rustic garden beds along the way. *Courtesy of Verlennich Masonry & Concrete*

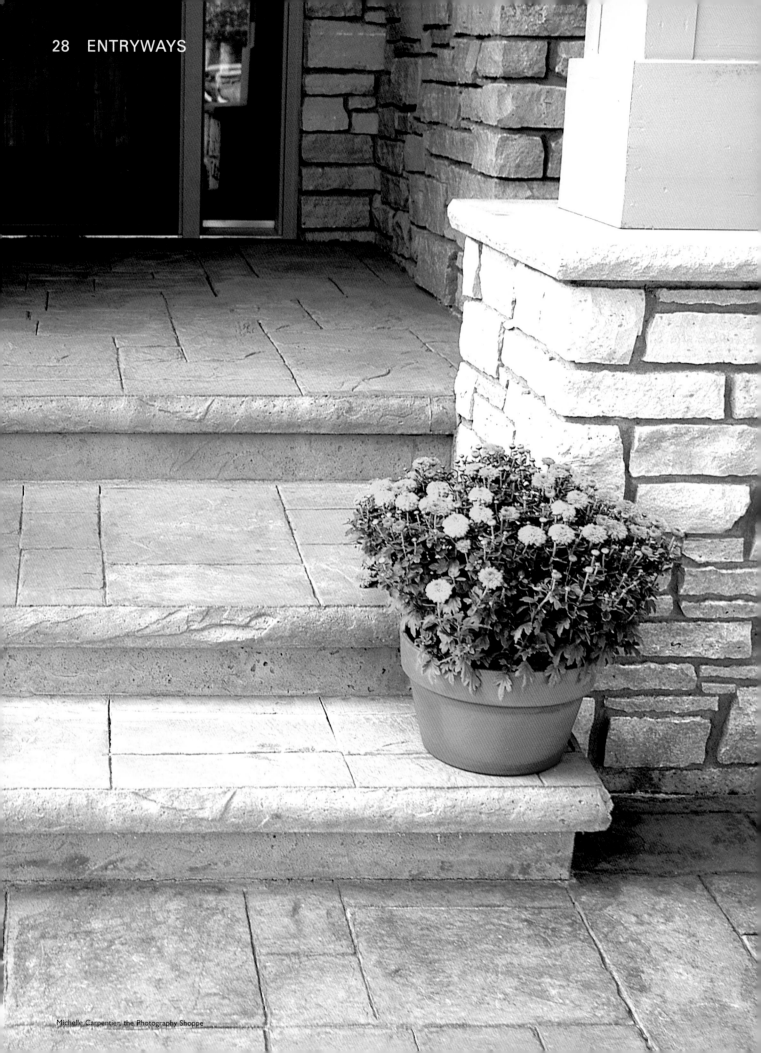

Michelle Carpentier, the Photography Shoppe

▲The rough treatment and earthy color given to these steps impart a warm, inviting feel to the project. *Courtesy of Classic Concrete*

◀The surface of this project is left purposely rough and makes the new entrance seem as if it has been a part of the house forever. *Courtesy of Classic Concrete*

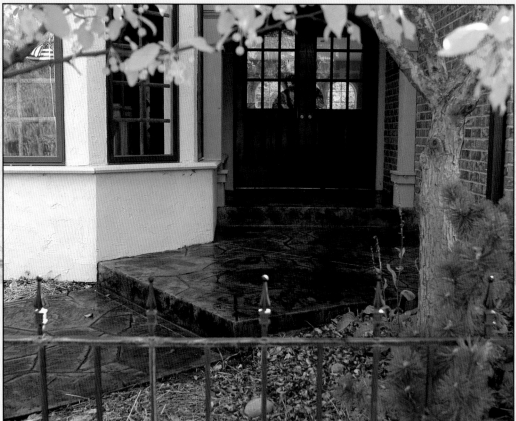

▶▼The colors chosen for this project contrast sharply with the white stucco and lead the eye to the stately, recessed entryway. *Courtesy of Classic Concrete*

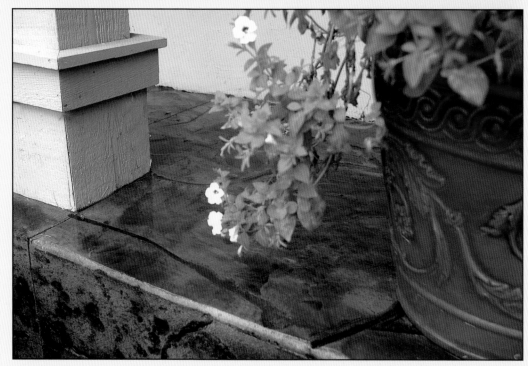

Michelle Carpentier, the Photography Shoppe

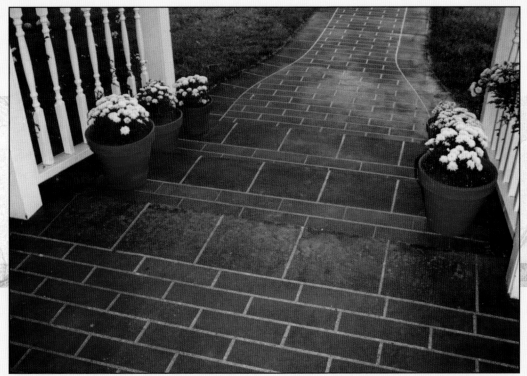

▲Larger sized "brick" etchings draw attention to the edges of a set of shallow steps. *Courtesy of Engrave-A-Crete™*

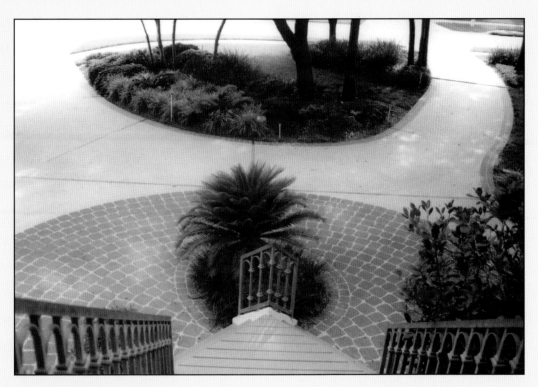

▲A cobblestone brick pattern fans out to the drive and walkway beyond. *Courtesy of Engrave-A-Crete™*

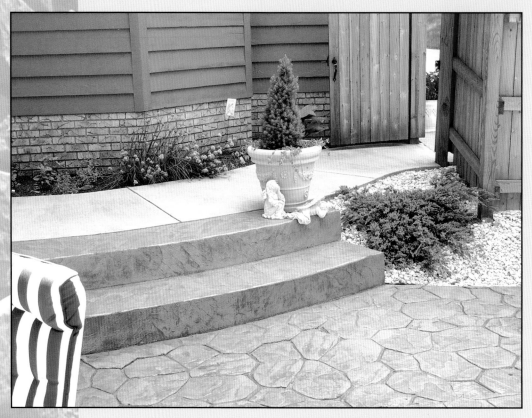

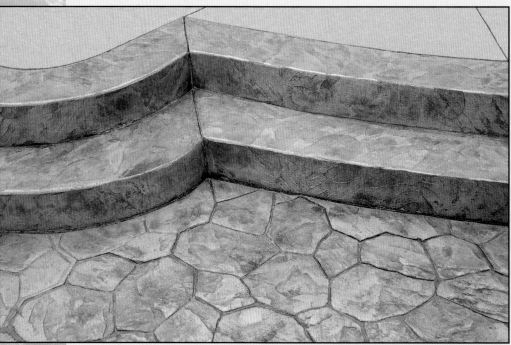

▲Versatile best describes concrete – equally at home on horizontal and vertical surfaces. *Courtesy of Bon Tool Co.*

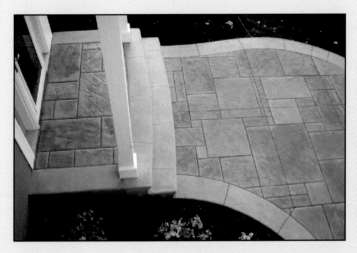
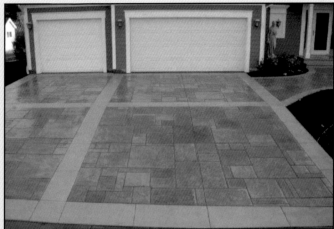

▲A walkway cast in an ashlar tile pattern makes a welcoming entryway into the home. The pattern is continued on the doorstep and driveway. *Courtesy of Bomanite Corp.*

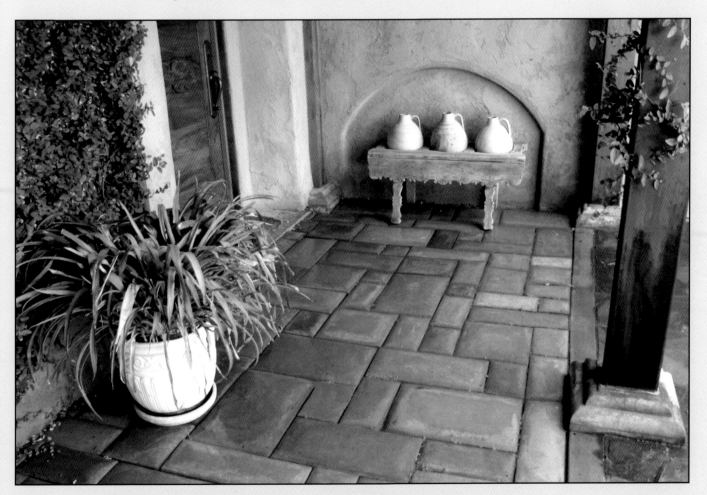

▲These concrete pavers were created using design molds to resemble Old World pavers. Dry-packing them in soil without filling in the joints with cement or grout allowed grass and moss to grow there, adding an authentic touch. *Courtesy of Sonoma Cast Stone*

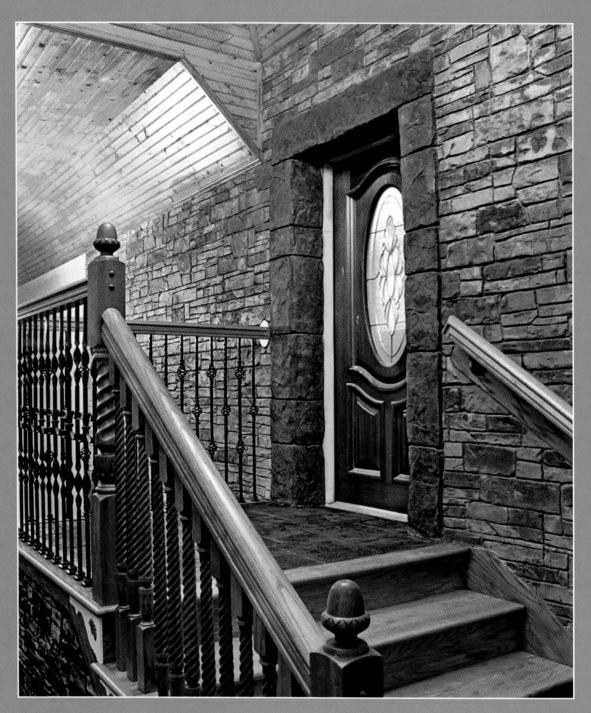

▲Light colored concrete facings contrast with the rich tones of wooden steps and railings. *Courtesy of Yoder & Sons LLC.*

Driveways

When homeowners build a new driveway, or revamp an existing one, many turn to concrete. Today, however, concrete choices venture far beyond the boring, old gray stuff. Concrete is the one material that does it all. It's versatile, durable, looks great, and is easy to maintain.

Today's homeowners take great pride in their home, and are fully aware of the "curb appeal" it exudes. One of the most effective ways to enhance the look of a home is by gracing it with a decorative driveway.

Because concrete can be forged into a range of textures, colors, and patterns, it is a versatile part of an overall landscape design and can increase the value of your home. Concrete can have the look, feel, and color of brick, slate, tile, or stone. This range of choices can complement a variety of exterior treatments of your house.

Concrete will hold up for a long time, with little maintenance required. Many concrete driveways last for thirty years or more, meaning in the long run it costs you less than other types of driveways. Decorative concrete contractors say decorative stamped concrete driveways cost less than using natural materials like flagstone, brick, or slate. Another advantage of concrete is that it will not sink or buckle like driveways made from other materials. And you won't have grass, dirt, or weeds growing up through the grout joints found in pavers, brick, or stone.

Freshly poured concrete driveways as well as existing driveways can be treated with colors and textures for a dramatic appearance. An existing driveway can be given a facelift with overlays, engraving, sawing, and/or scoring.

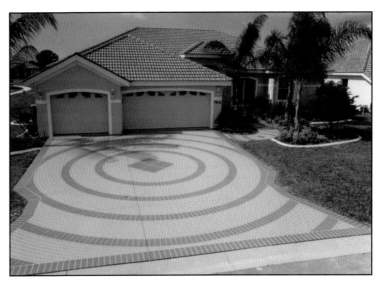

▲ Brick lacings ripple out from the center of this driveway. *Courtesy of Engrave-A-Crete*™

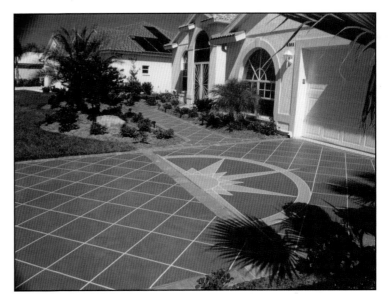

▲ Half a compass rose provides a compelling invitation for this driveway. *Courtesy of Engrave-A-Crete*™

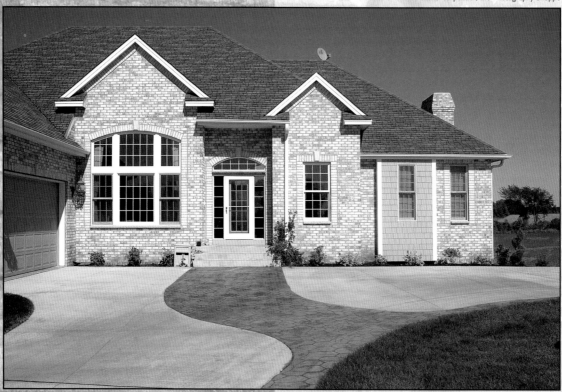

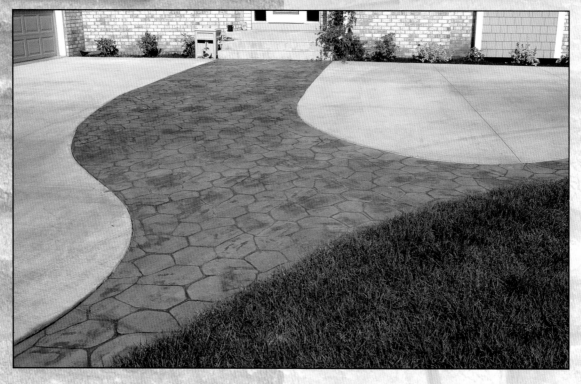

Two separate treatments define this space: the sweeping curves of the walkway extend an invitation to the entrance, while the driveway space is colored to blend in with the garage and light colored brick. *Courtesy of Classic Concrete*

Michelle Carpentier, the Photography Shoppe

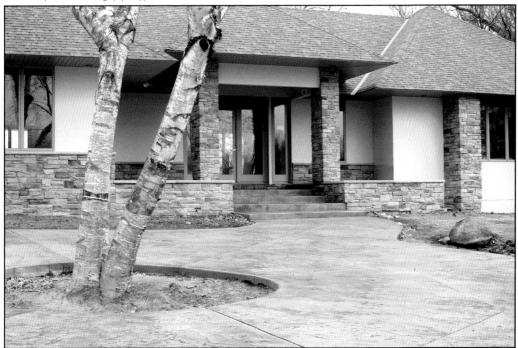

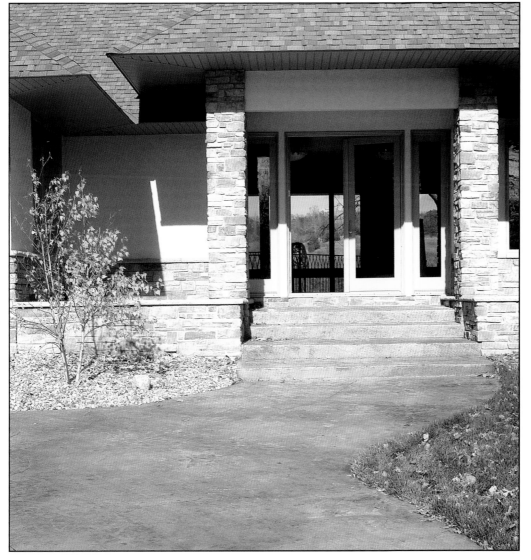

◀▲▲The sun warms the circular drive and entrance and allows this home to blend with surrounding natural elements. *Courtesy of Classic Concrete*

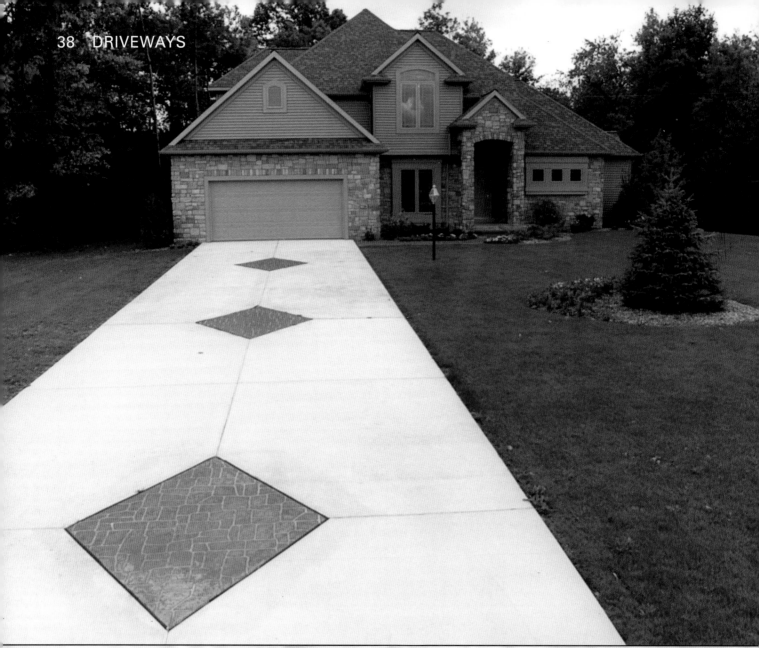

This driveway is ornamented by "stone" insets. The diamond insets work with the score lines imperative in any expanse of concrete to control natural cracking. *Courtesy of DCI*

To heighten the impression of slate, the individual parts of the pattern were carefully hand-colored. *Courtesy of Bomanite Corp.*

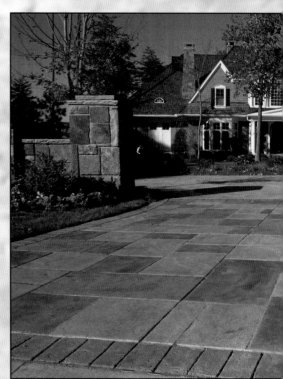

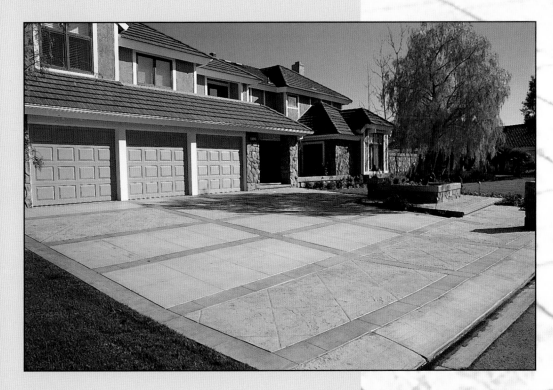

A large parking deck allowed these homeowners to decorate their drive-way with multiple patterns. *Courtesy of Bomanite Corp.*

The random pattern of this driveway and walkway mimic real stone blending with the natural surroundings and rustic style of the dwelling. *Courtesy of Verlennich Masonry & Concrete*

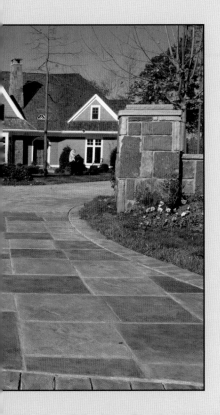

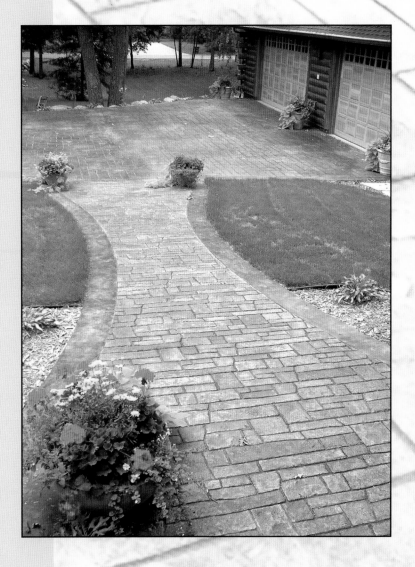

▶ A dark color was applied to "grout" oversized squares, adding to the appeal of this expansive courtyard. *Courtesy of Sullivan Concrete*

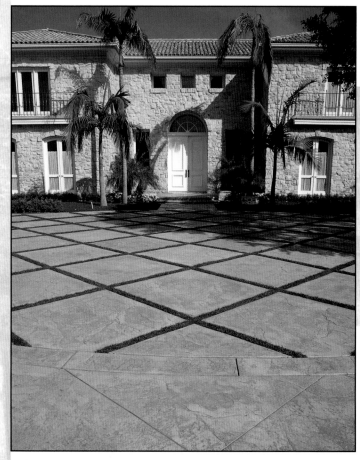

▼ An expanse of driveway and parking area takes on the natural tones of the desert, with warm stains to break up the distance. *Courtesy of Artscapes*

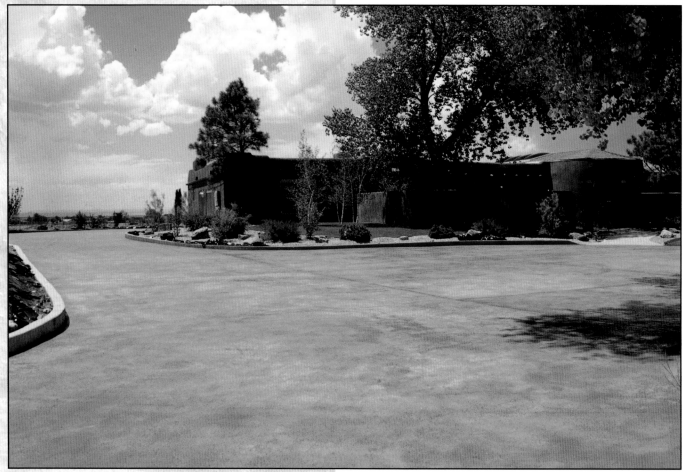

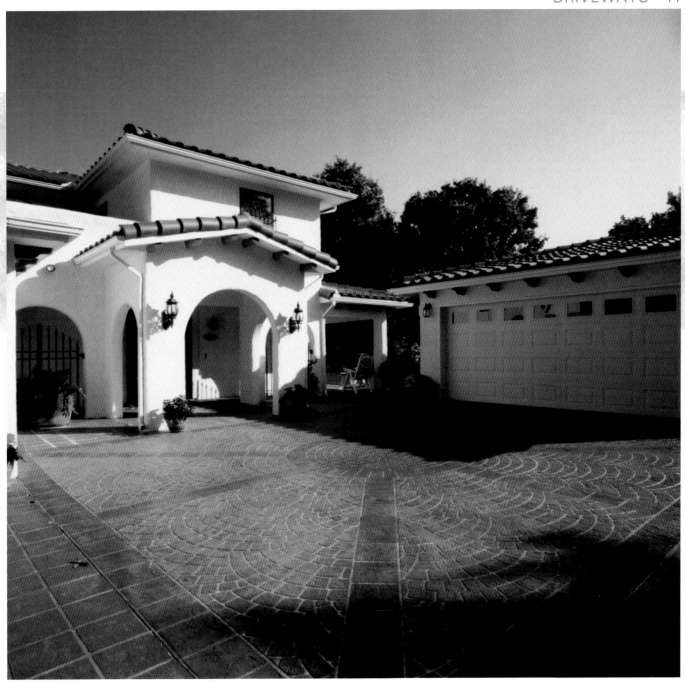

▲ This expansive driveway/parking area creates a grand entrance and provides an elegant entertaining area for large gatherings. *Courtesy of DCI*

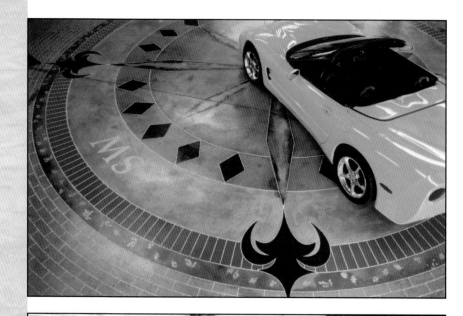

▶Leaves along the border heighten the wind theme of a compass rose. *Courtesy of Engrave-A-Crete™*

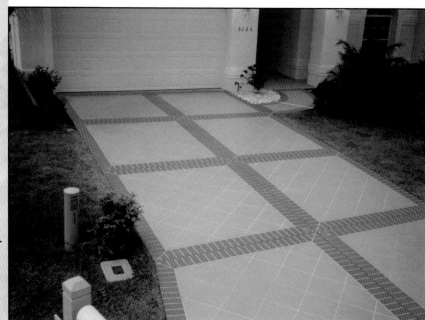

▶Brick patterns take turns tracing circles around this drive and entryway. *Courtesy of Engrave-A-Crete™*

▶Etched and stained concrete imitates terra cotta tiles framed by bricks. *Courtesy of Engrave-A-Crete™*

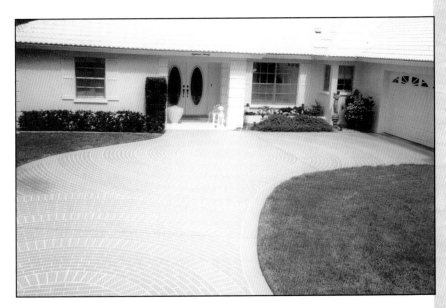

Circles of brick lacing ripple like water on this driveway. *Courtesy of Engrave-A-Crete™*

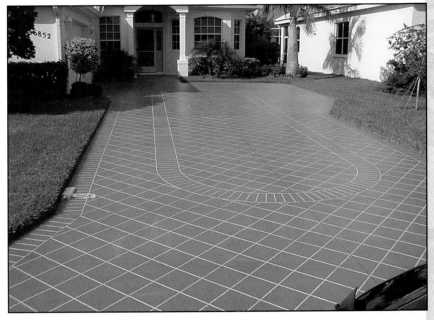

Brick lacing in the middle of the driveway outlines a space where the car can park. *Courtesy of Engrave-A-Crete™*

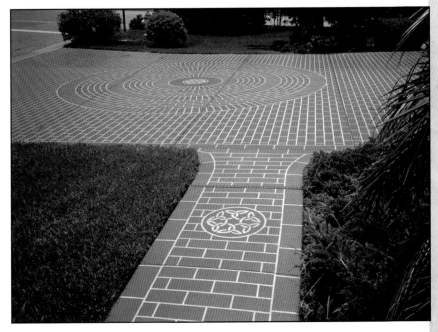

Twists of Celtic knotwork stand out amidst the straight lines created by faux brick. *Courtesy of Engrave-A-Crete™*

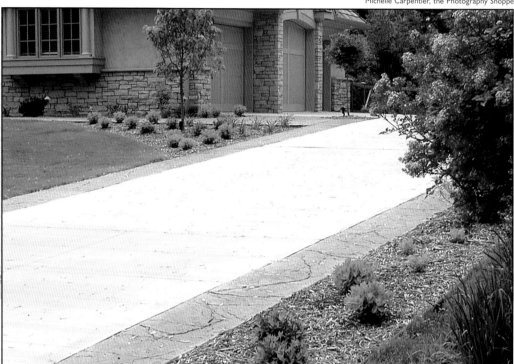

▶▲ Understated appeal. A money-saving option is to simply use decorative techniques to trim or border an expanse of concrete slab. Here, a broad driveway is dressed up with faux stone runners. *Courtesy of Classic Concrete*

▶ Contrasting color and texture break up the expanse of a generous drive and parking deck, and create a welcoming environment. *Courtesy of Verlennich Masonry & Concrete*

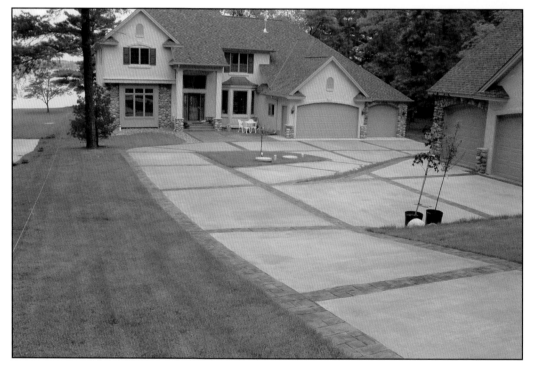

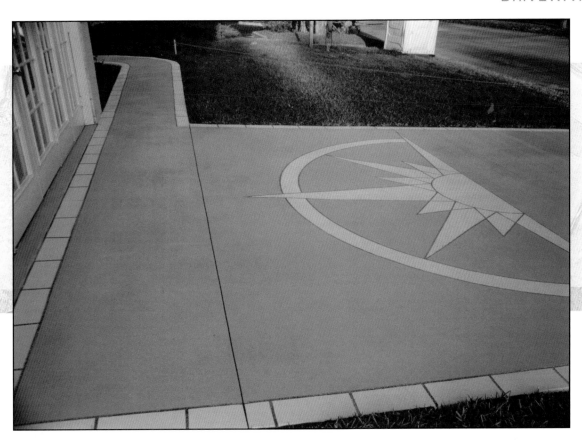

▲Half a compass rose shows the way to the house. *Courtesy of Engrave-A-Crete*™

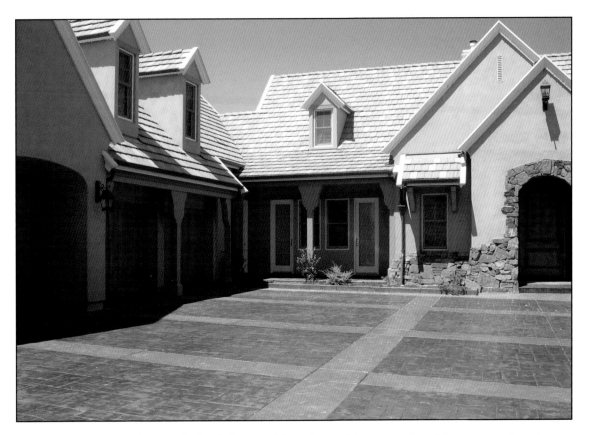

▲Two textures and tones help define and break up this expansive driveway and parking deck. *Courtesy of The Concrete Colorist*

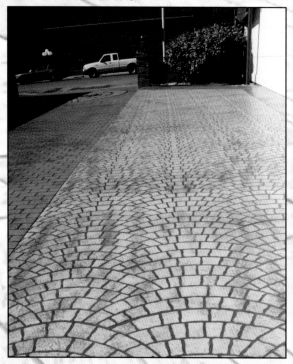

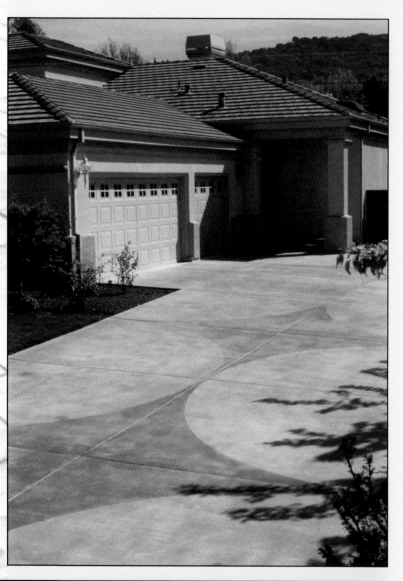

▲A European fan pattern denotes parking spaces beside a basket-weave brick pattern in a complementary color tone. *Courtesy of DCI*

▶A concrete slab driveway was dressed up with a light application of pigment. This simple graphic pattern adds wow factor to an otherwise nondescript expanse of concrete. *Courtesy of The Concrete Colorist*

▶This driveway was cast to resemble single sheets of rock, and is further accentuated by similar colored borders. *Courtesy of Bomanite Corp.*

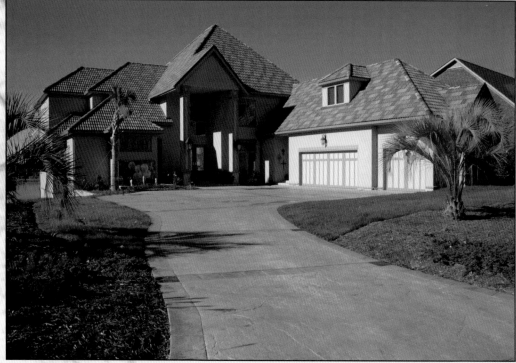

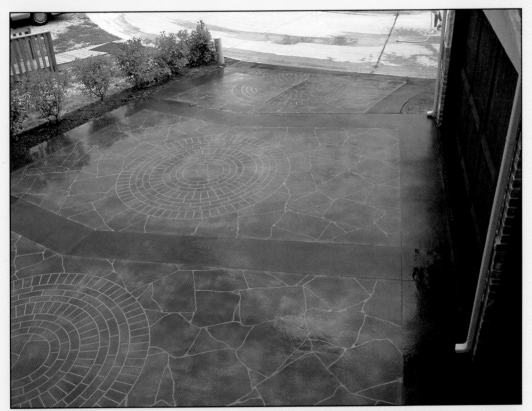

◀An engraved driveway has been finished to a high gloss. The coloring, patterns, and sheen make this approach very memorable. *Courtesy of The Ultimate Edge, Inc.*

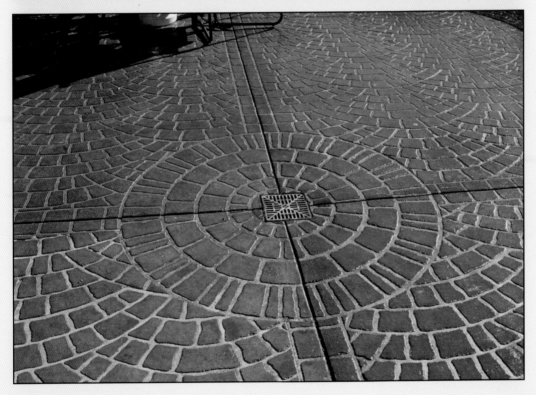

◀A patio area is carefully crafted to avoid standing water, with the runoff drain serving as a decorative focus within a stenciled pattern of "cobblestones." *Courtesy of DCI*

Walkways

Walkways around the home serve to unify architecture and landscaping. They marry the environments we pass through, from driveway to portal, side gate to patio, and invite us to pass through gardens, past statuary, and beyond. Careful thought and planning for walkways will result in a pleasing package for the property, and a lawn that enjoys more thorough use in the long run.

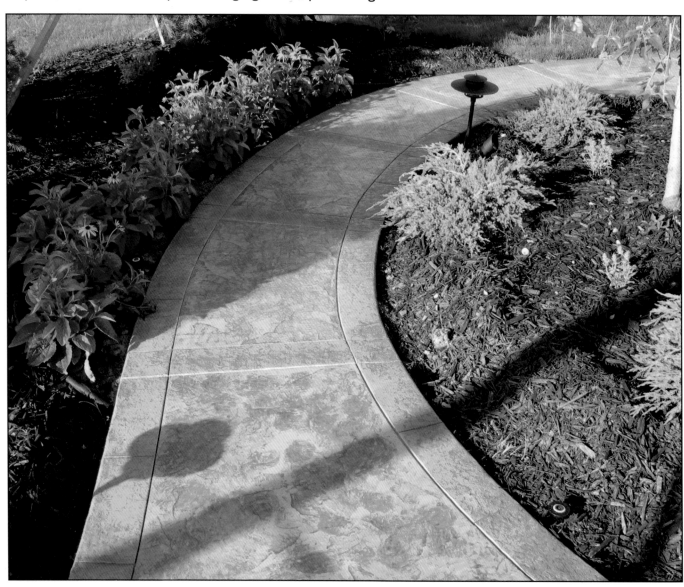

▲ This walkway was given subtle texture and pattern, in keeping with its natural surroundings.
Courtesy of Courtesy of Action Concrete Services

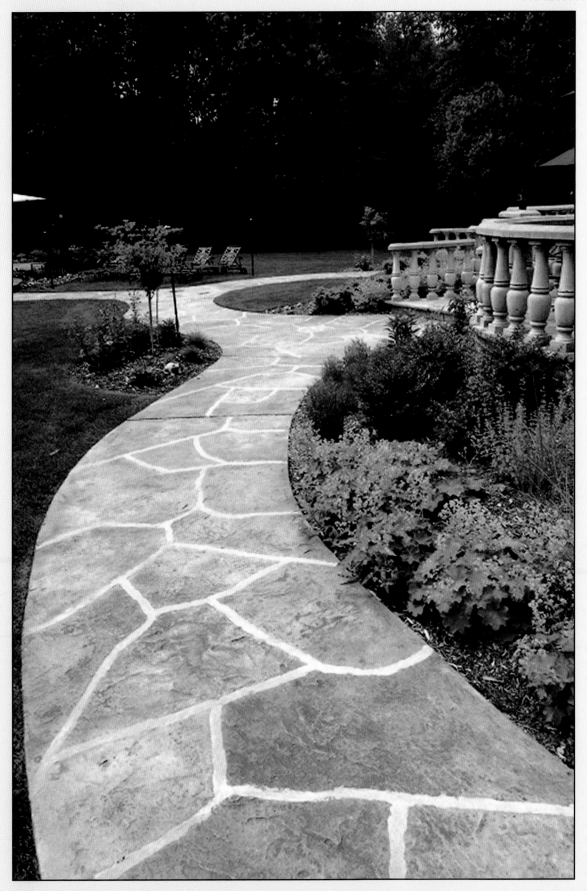

A random stone pattern creates an inviting pathway through a backyard.
Courtesy of Concrete Concepts Inc.

A faux-rock walkway winds its way through staggered planting beds created by curved retaining walls. *Courtesy of DCI*

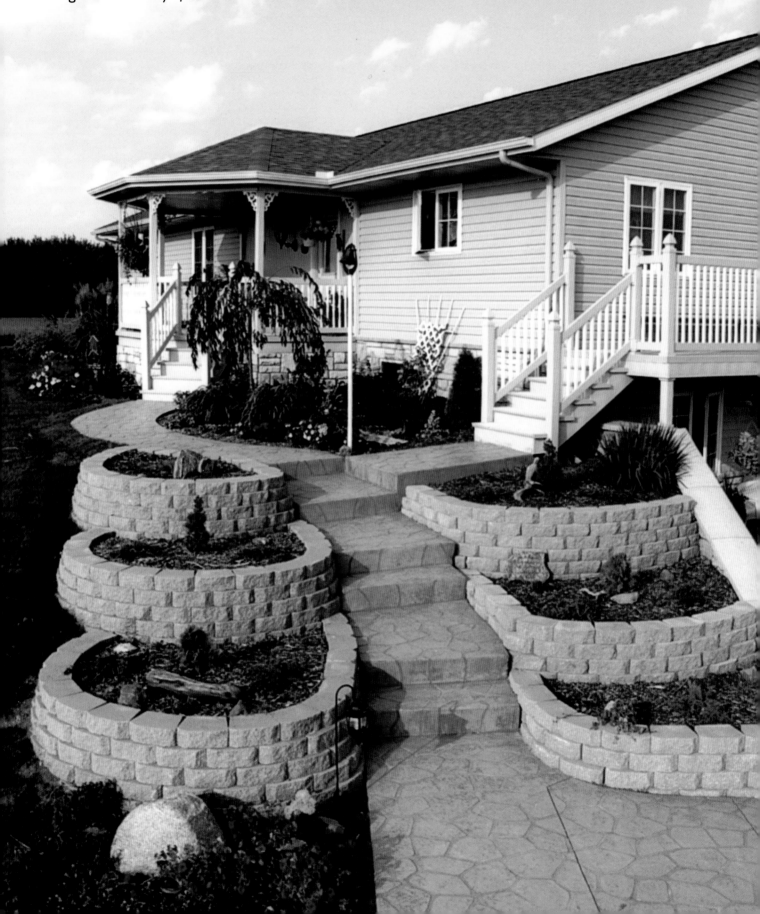

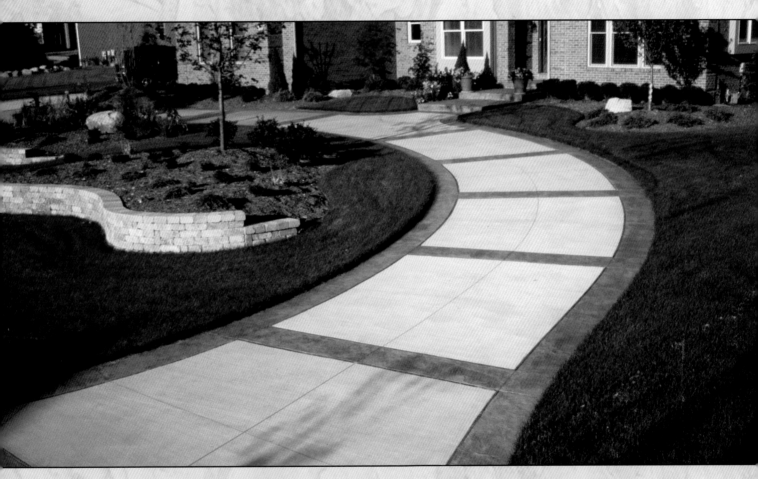

▲This wide, curving concrete path adds formal character and heightens the "curb-appeal" of this home. *Courtesy of Courtesy of Action Concrete Services*

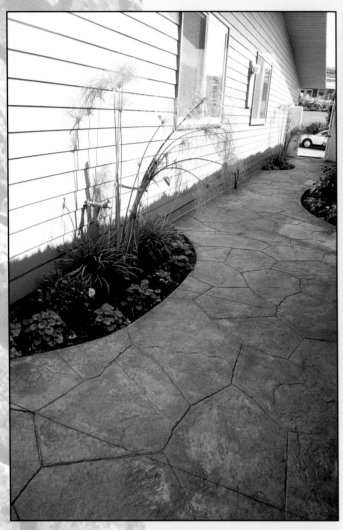

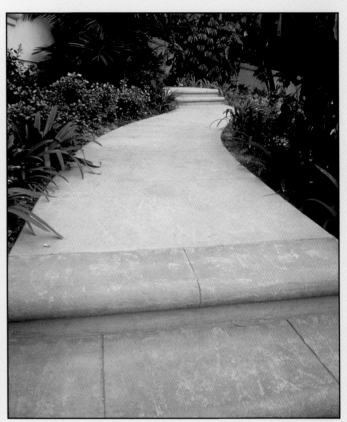

A winding walkway is tipped with bull-nosed steps in concrete stained one shade darker. *Courtesy of Sullivan Concrete*

Clean concrete wraps a home, with curves and cutouts for the gardener. *Courtesy of Sullivan Concrete*

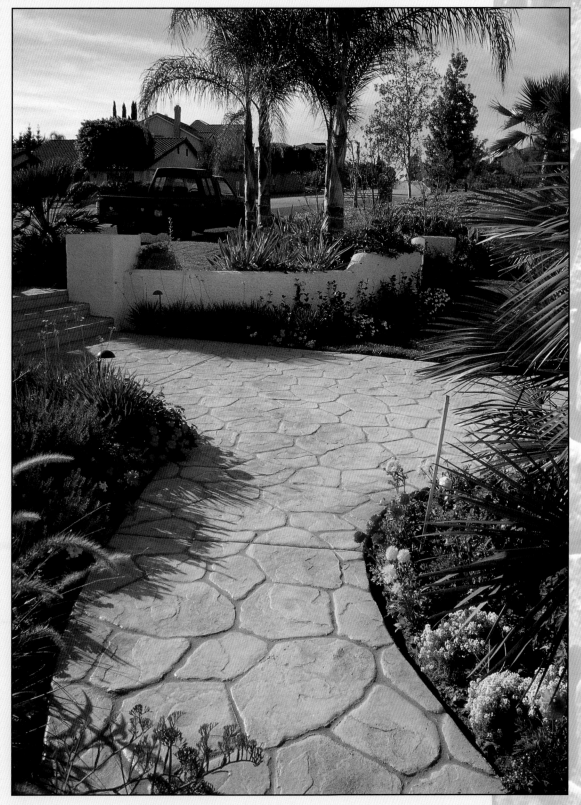

▲A wandering "stone" walkway wends its way through gardens.
Courtesy of Sullivan Concrete

▶ This herringbone-patterned walkway welcomes visitors. *Courtesy of Courtesy of Action Concrete Services*

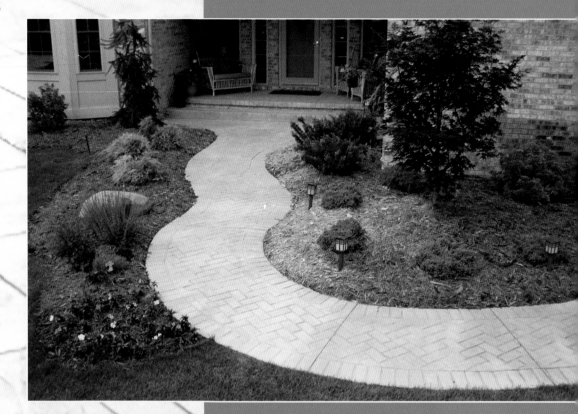

▶ No invasive weeds will mar the beauty of this "brick" walkway and patio. *Courtesy of Courtesy of Action Concrete Services*

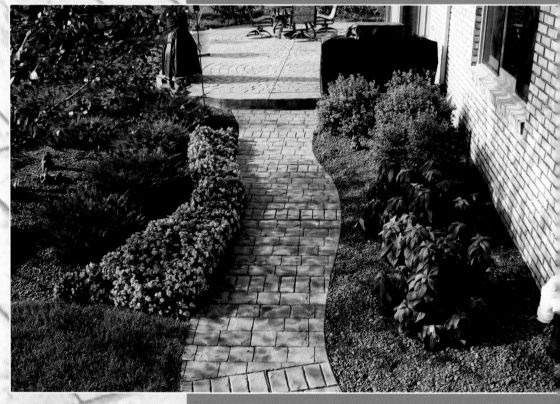

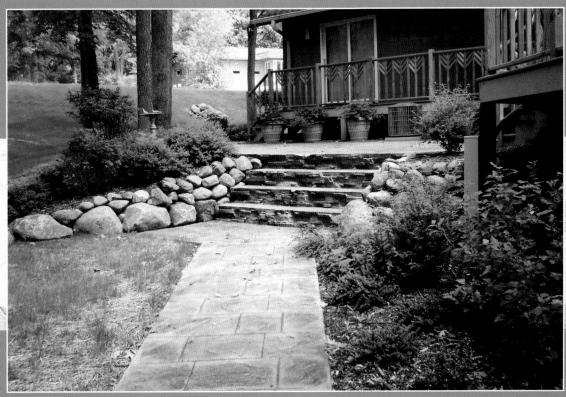

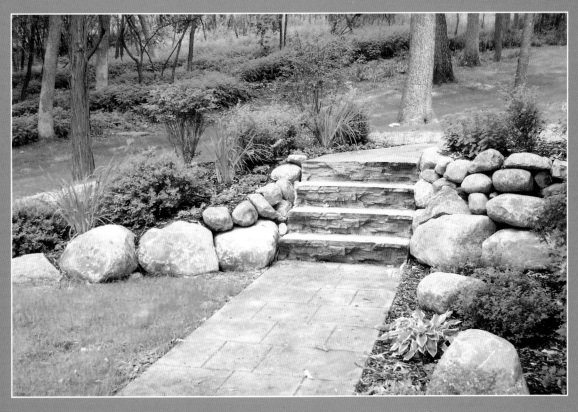

▲The pattern stamped on this walkway is designed to imitate cobble-stones. *Courtesy of Bomanite Corp.*

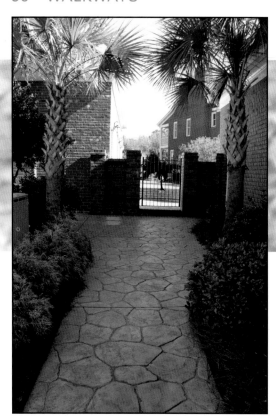

Colored gray and stamped in a flagstone pattern, this concrete walkway mimics the appearance of a stone path. *Courtesy of Bomanite Corp.*

▶A narrow walkway is given maximum appeal with texture and stain that add up to a real stone impression. *Courtesy of Sullivan Concrete*

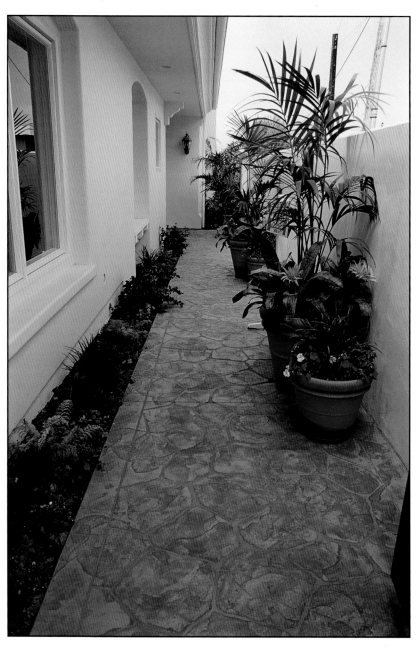

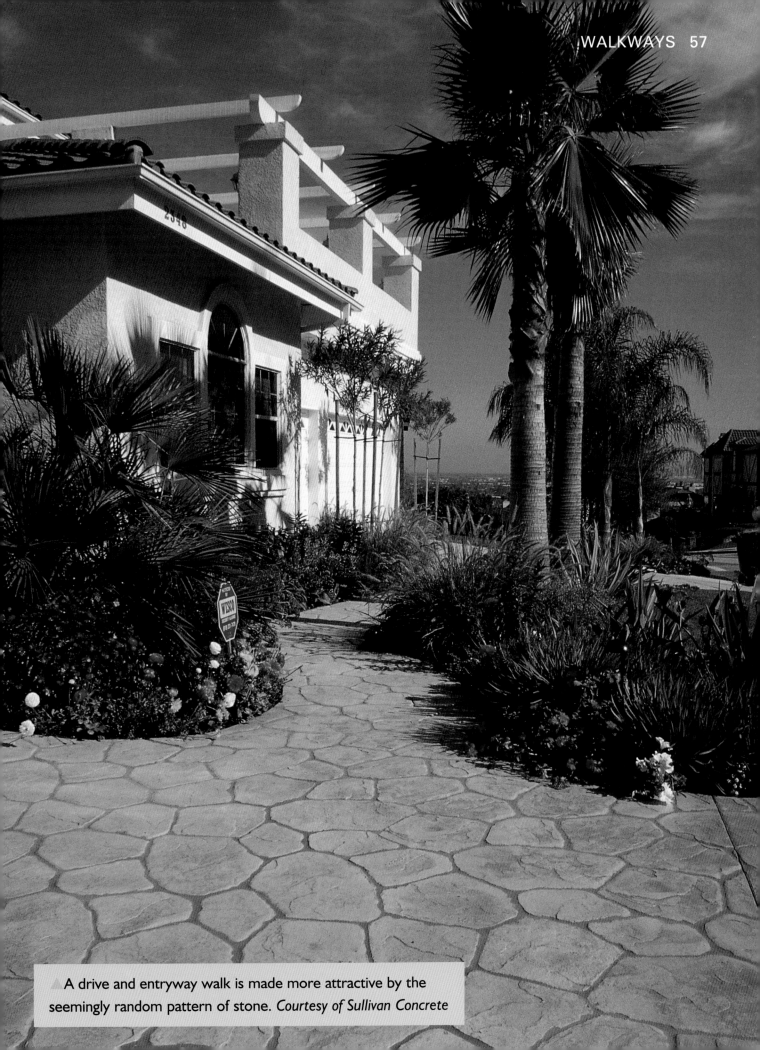

A drive and entryway walk is made more attractive by the seemingly random pattern of stone. *Courtesy of Sullivan Concrete*

Michelle Carpentier, the Photography Shoppe

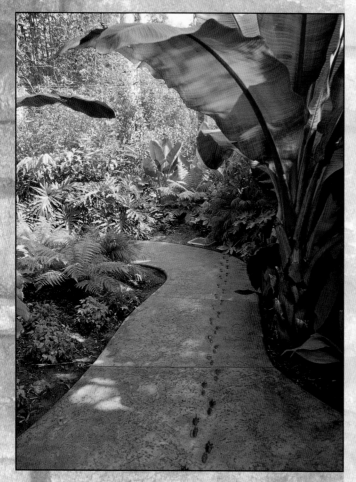

It would appear that some creature walked through an expanse of prehistoric mud, now hardened and serving as a pathway through the jungle. *Courtesy of Sullivan Concrete*

▲ A flagstone landing has been imbued with terra cotta hues. *Courtesy of Classic Concrete*

Michelle Carpentier, the Photography Shoppe

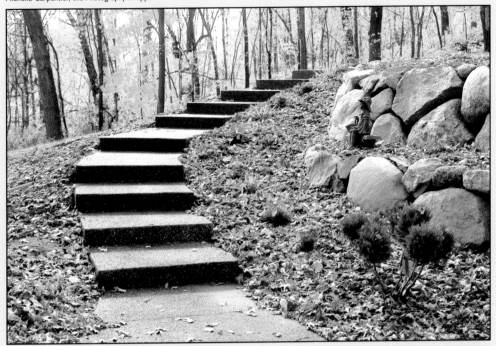

▲A gradual stone staircase mimics carved granite. *Courtesy of Classic Concrete*

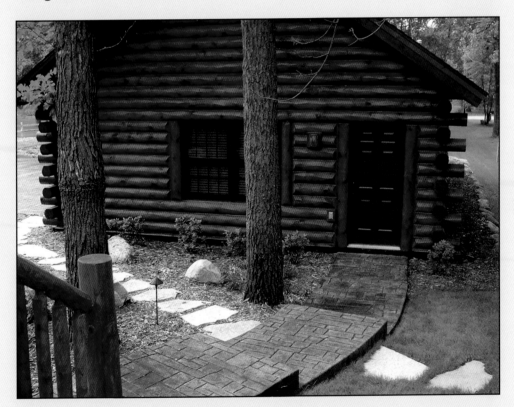

▲With an authentic log cabin at its base, a simple concrete walk wouldn't suffice, so it was dressed up to imitate flagstone. Leading from the cabin door up a steep slope, this stepped-up path provides comfortable walking and firm footing. *Courtesy of Verlennich Masonry & Concrete*

▲This stamped brick walkway leads from the corner of the house to an intimate patio in the back. The straight lines of the walk are softened by the gentle curves of the patio. *Courtesy of Verlennich Masonry & Concrete*

Patios

Americans everywhere, from California to New England, from Texas to Minnesota, are spending more time at home and more time outdoors. Backyards are being transformed into luxurious extensions of the house. They're the new favorite room to relax, entertain, and cook in. And the heart and soul of the backyard resort area is the concrete patio.

Homeowners want to enjoy their homes, but they also see upgrading their backyards as an investment. When homeowners embark on building their outdoor oasis, they typically envision a range of features. Many want a total package – a backyard retreat in which they can escape and relax at the end of the day and on weekends.

The first thing most people start with is the concrete patio. Rest assured, it's not just the plain old gray anymore. Today's backyard concrete patios are as unique as its owners. Modern stamping and texture and coloring techniques complement any landscape and provide a touch of individuality to your backyard.

Across the country, companies that specialize in concrete patios are seeing an enormous increase in elaborate outdoor living spaces – all kinds of hard-scaping and landscaping projects. "It's booming," says Lawson Edwards of Concrete Creations in Moore, Oklahoma. "Every year I think it can't get any bigger, and it does. You don't have to settle for the old gray stuff anymore."

▶The stamped concrete deck enhances the formality this home's brick exterior. The balusters, too, are concrete, creating a solid and decorative safety rail around the raised platform. *Courtesy of Courtesy of Action Concrete Services*

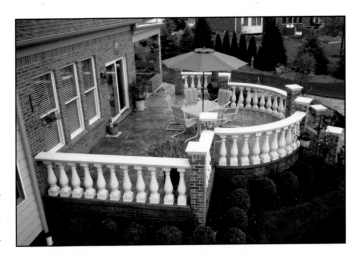

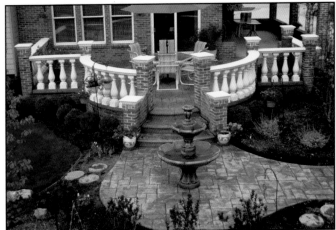

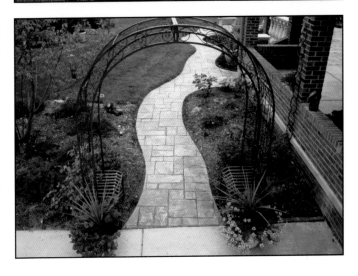

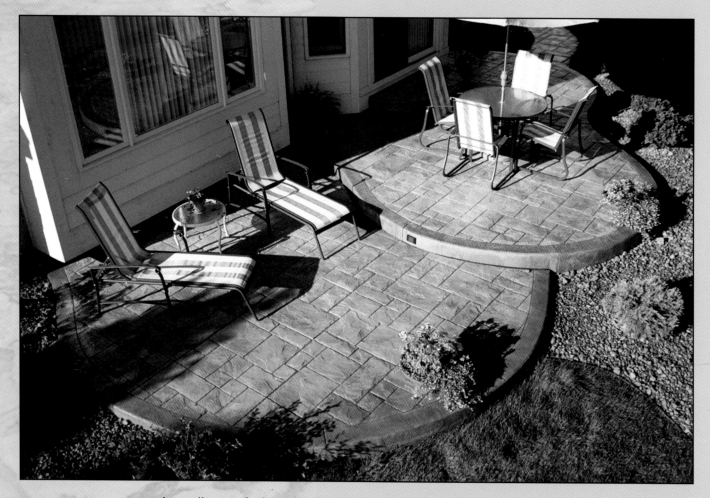

A small patio feels more expansive when divided into two platforms.
Courtesy of Courtesy of Action Concrete Services

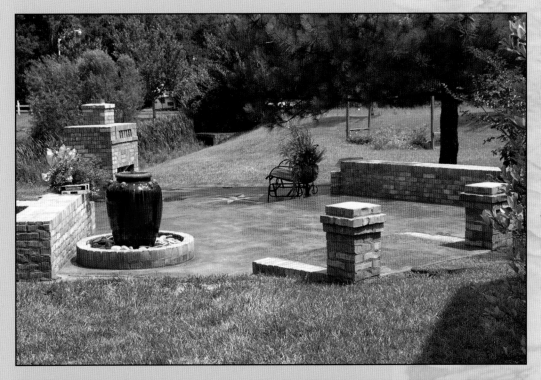

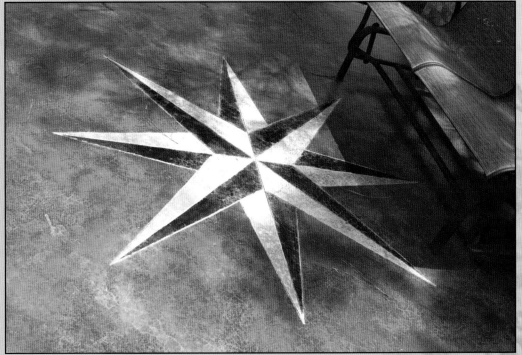

These homeowners created a multi-level "island" entertainment area complete with outdoor fireplace, a water feature, and low walls, which define boundaries and double as seating. *Courtesy of Creative Concrete Staining & Scoring, LLC*

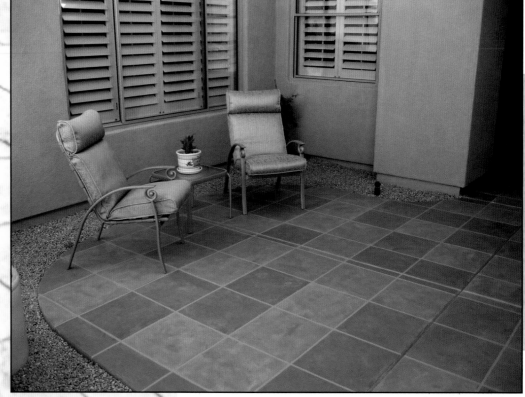

▶ Red and tan faux flagstones make the porch an inviting place to sit and chat with the neighbors. *Courtesy of XcelDeck™*

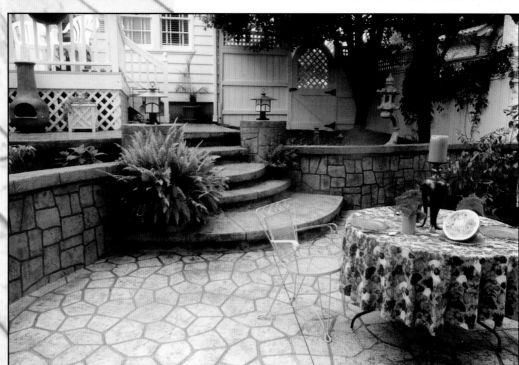

▶ Faux-rock finish for the retaining walls, patio floor, and steps unifies this charming gathering spot. *Courtesy of DCI*

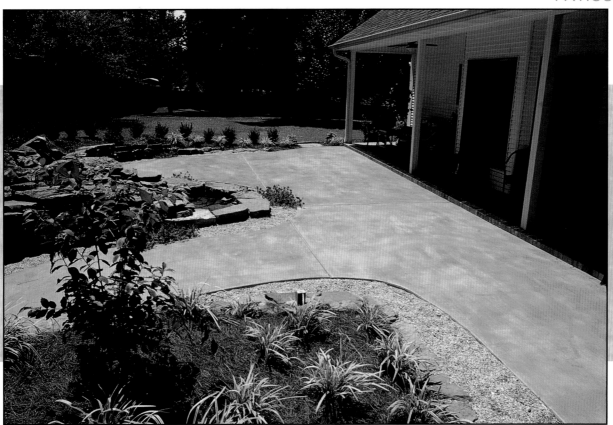

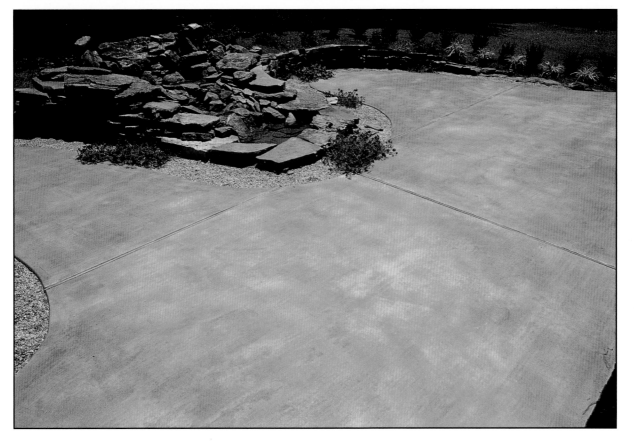

▲ A pigmented concrete patio draws attention to a garden and an ornamental rock formation. *Courtesy of Images in Concrete*

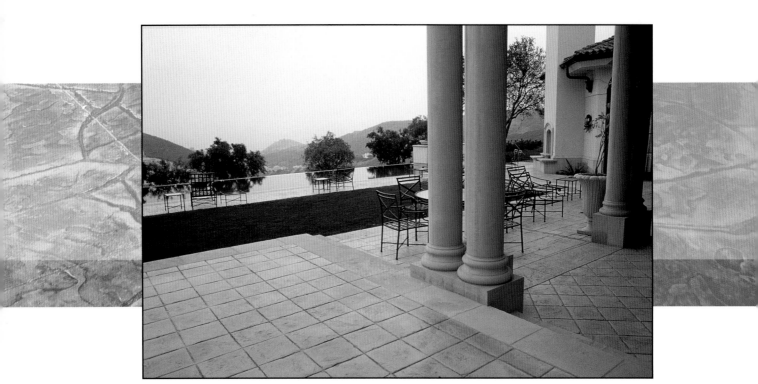

▲A tile pattern is set in varied directions to help establish zones in this expansive series of outside "rooms." *Courtesy of Sullivan Concrete*

Michelle Carpentier, the Photography Shoppe

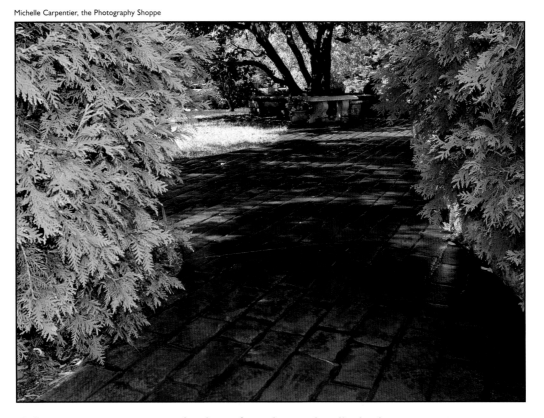

▲An inviting resting space beckons from beneath tall, shady trees.
Courtesy of Classic Concrete

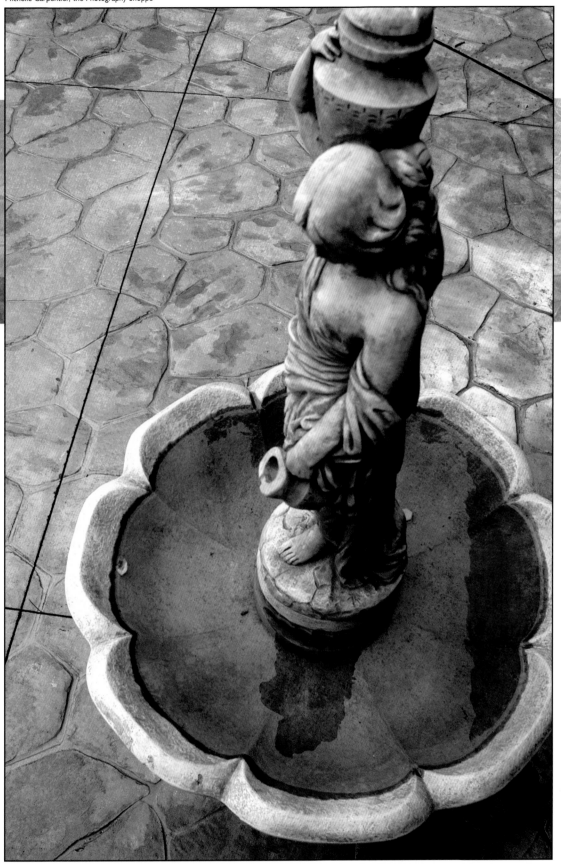

▲The variegated color and random texture of this design evokes the feeling of antiquity and gives this space Old World charm. *Courtesy of Classic Concrete*

Michelle Carpentier, the Photography Shoppe

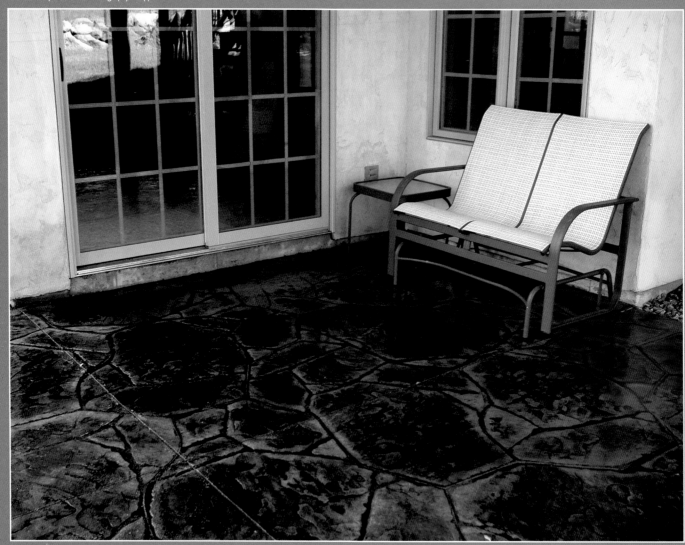

▲A quick sweep with the broom or a damp mop is all that is needed on this
easy-care surface. Children and pets alike are welcome to use this entrance.
Courtesy of Classic Concrete

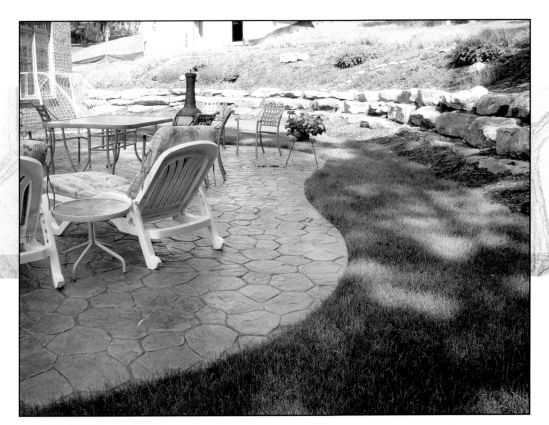

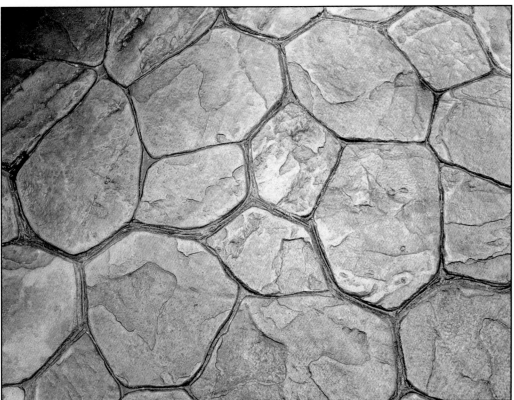

▲ This natural stone pattern, with variations in size and texture of the pattern, allows the patio to blend into its natural surroundings. The color was chosen to work with the natural stone of the retaining wall that surrounds it. *Courtesy of Bon Tool Co.*

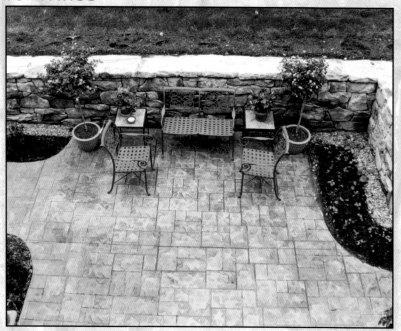

This seating area nestles in a corner of the patio. The faux flagstone pattern lends an air of formality, as does the symmetrical placement of the furniture. *Courtesy of BonTool Co.*

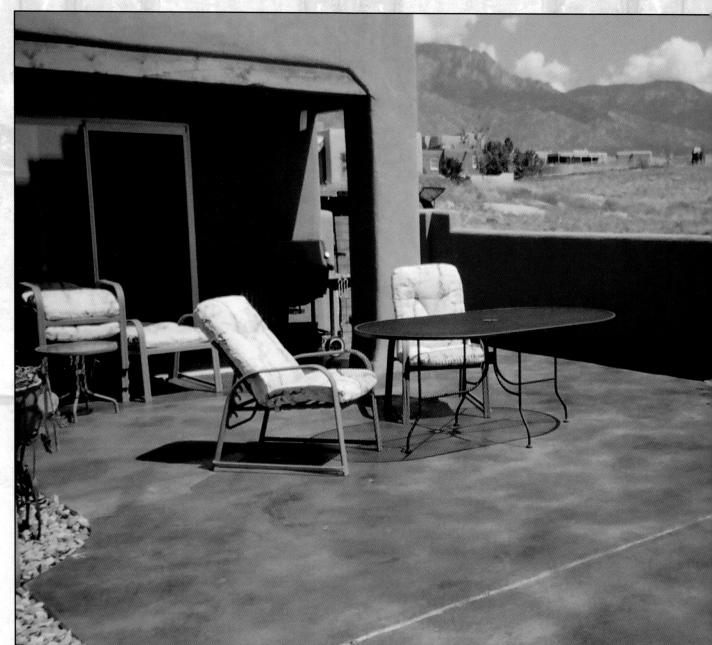

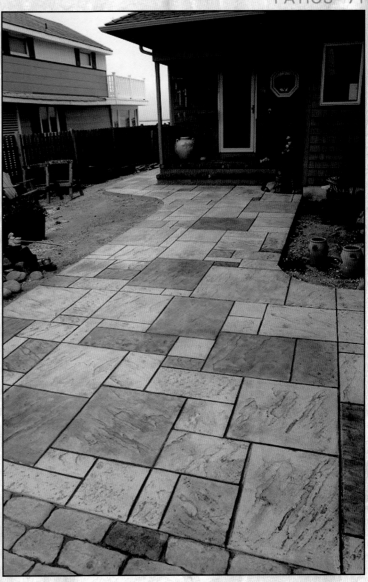

▶Flagstone effect is masterfully crafted, with stains that are carefully applied to create separate "stone" and black "grouting" to add definition. *Courtesy of Concrete Concepts Inc.*

◀An exterior patio becomes inviting when softened with layered tones of acid stain for a rich, earthy effect. *Courtesy of Artscapes*

▶ Terracotta tones in the concrete patio pad work with wood and stucco to provide a warm horizontal accent in a contemporary adobe atmosphere. *Courtesy of Artscapes*

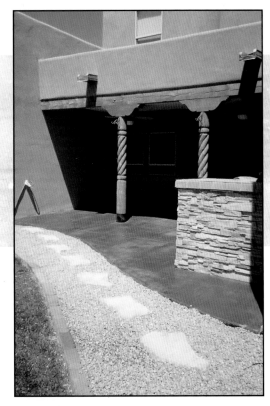

▼ Two colors and two textures work together to define this sweet little swoop of patio. *Courtesy of Specialty Concrete Designs*

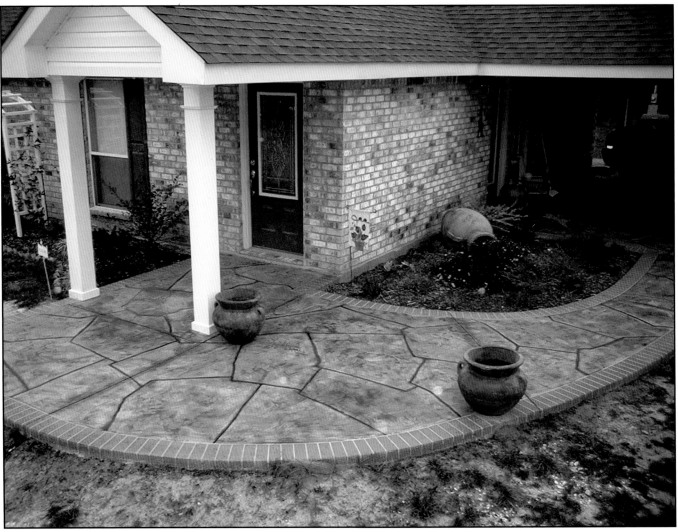

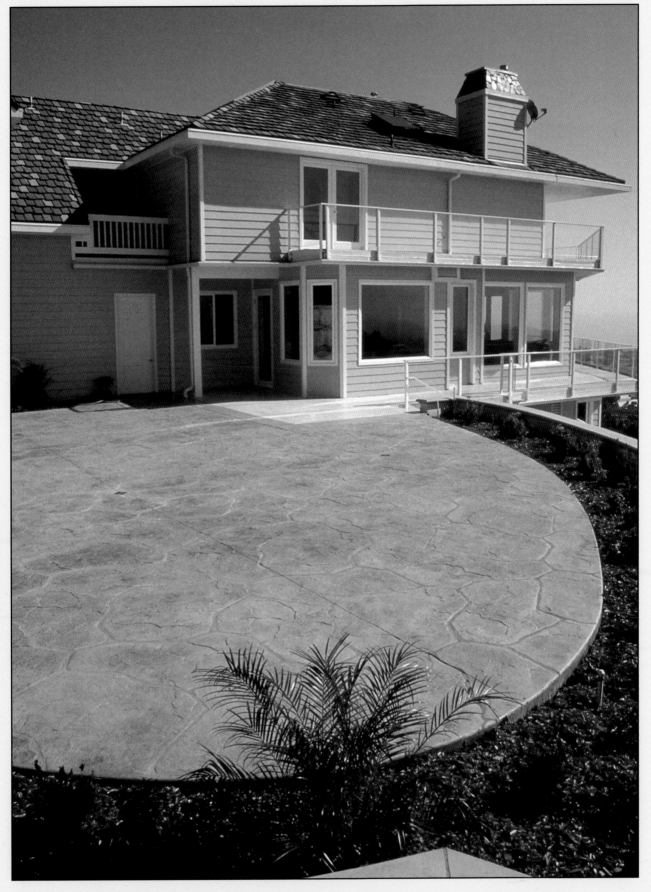

▲An expanse of new patio was pressed to represent random-pattern brown-stone. *Courtesy of Sullivan Concrete*

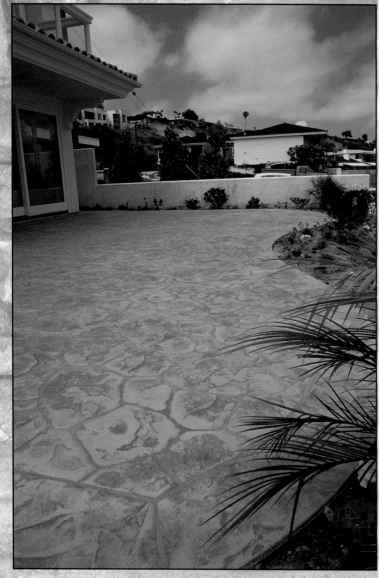

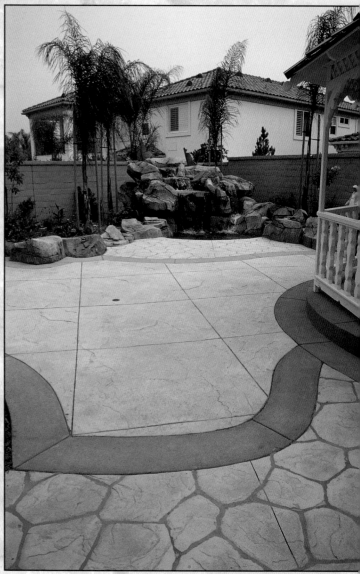

Though indeed it does have some of the texture found in natural stone, stamped concrete offers a more level playing surface and proves less hazardous for those treading its surface. *Courtesy of Sullivan Concrete*

Grey accent stripes vary the scenery, and matching "boulders" form a backdrop for this inviting concrete patio. *Courtesy of Sullivan Concrete*

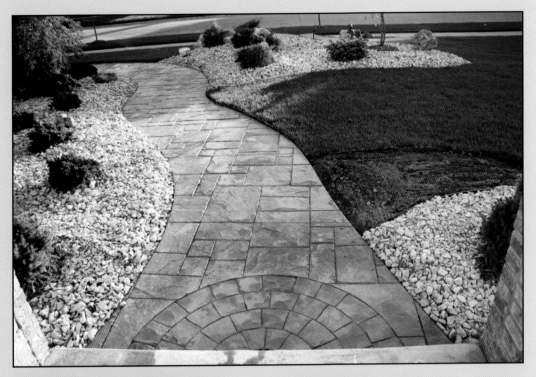

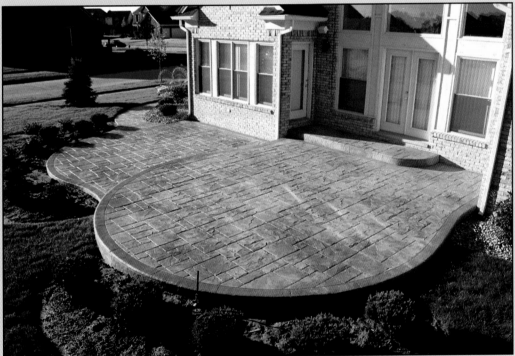

▲The continuous use of pattern creates the cohesive unit of this patio and wrap-around walkway. *Courtesy of Courtesy of Action Concrete Services*

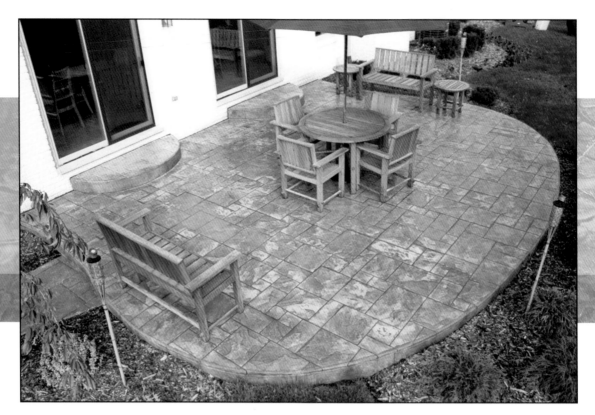

▲The beauty of this outdoor space is as much in its ease of care as in the beautiful color and texture. *Courtesy of Courtesy of Action Concrete Services*

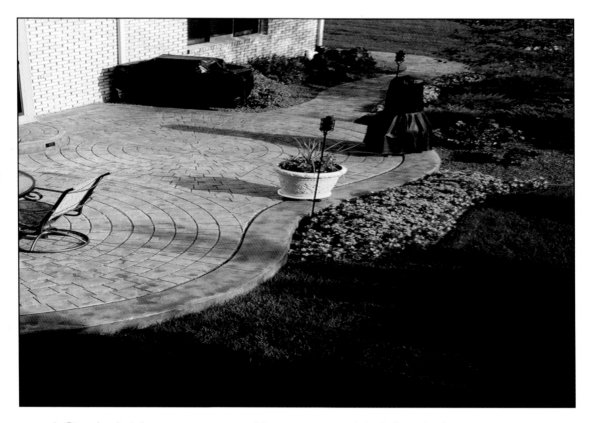

▲Circular brick patterns stamped in a concrete slab define the living spaces. *Courtesy of Courtesy of Action Concrete Services*

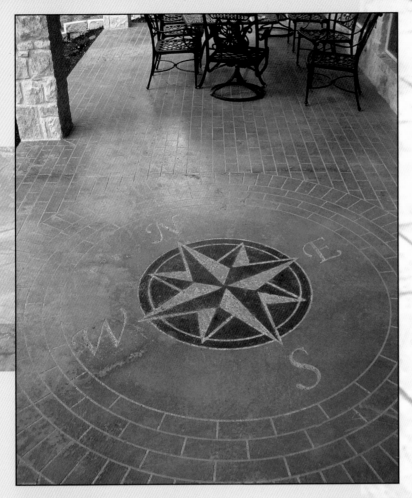

A compass star adorns a patio, stenciled and stained to mimic a brick patio with the patina of many years. *Courtesy of The Ultimate Edge, Inc.*

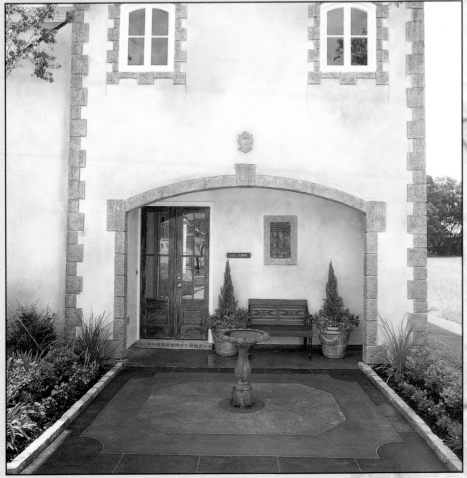

Three complementary colors and patterns add drama to this small courtyard. *Courtesy of Kemiko Concrete Stains*

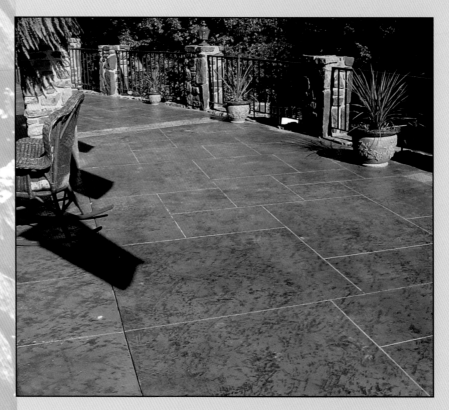

▲ An expanse of faux flagstone is softened with a contrasting color. *Courtesy of DCI*

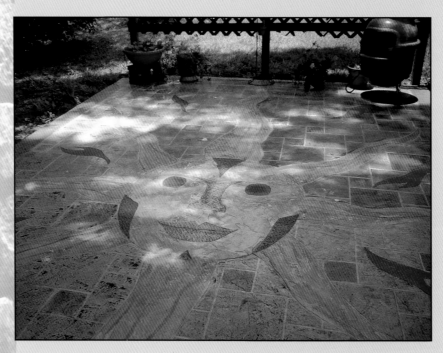

▲ A contractor was allowed to unleash his creativity with this colorful, happy sun motif. *Courtesy of Specialty Concrete Designs*

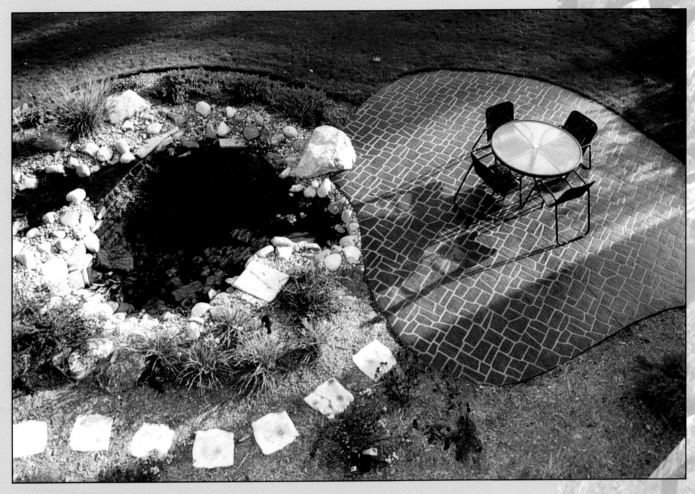

▲The small seating area echoes the shape of the water feature. Firm footing is provided by concrete stenciled and textured in a random-size stone pattern. *Courtesy of DCI*

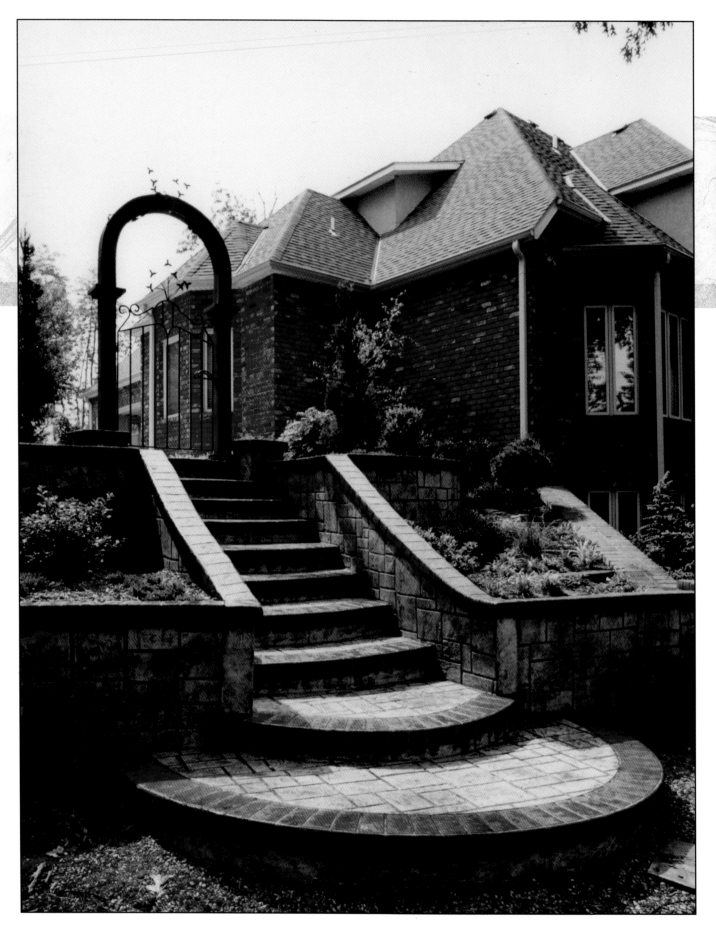

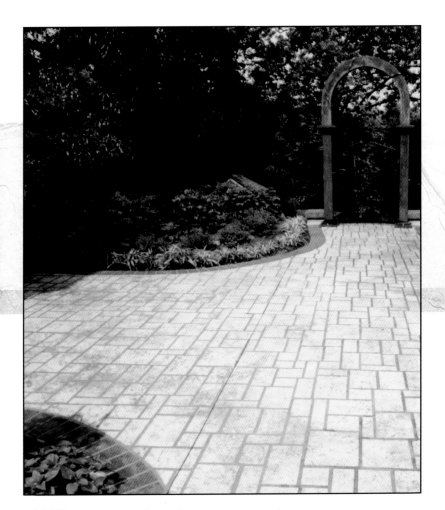

◀▲ The transition from lower courtyard to upper commons area is neatly achieved with concrete landing, steps, and planted retaining walls. *Courtesy of DCI*

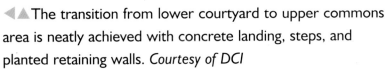

A stained and scored patio reflects the homeowner's love of all things rustic and adventurous. *Courtesy of Advanced Surfacing*

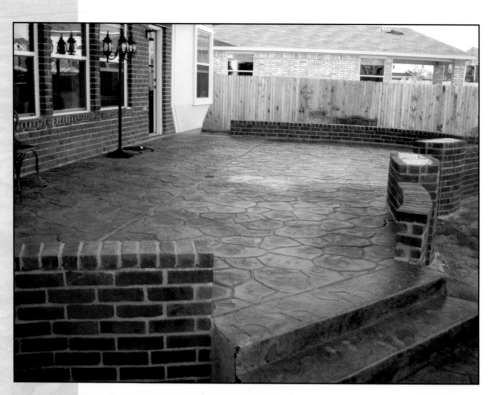

A patio was stamped with a random stone design and flanked with real brick masonry to match the existing house. The brick wall is more than aesthetic; it was built 18-20 inches above patio level, perfect for seating. *Courtesy of Advanced Surfacing.*

Rather than using traditional white paint to define the lines on this basketball court, they have been stained into the concrete pad. Not only is it more attractive, they will never need to be re-done. *Courtesy of Creative Concrete Staining & Scoring, LLC*

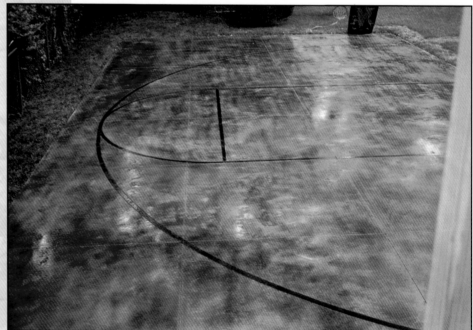

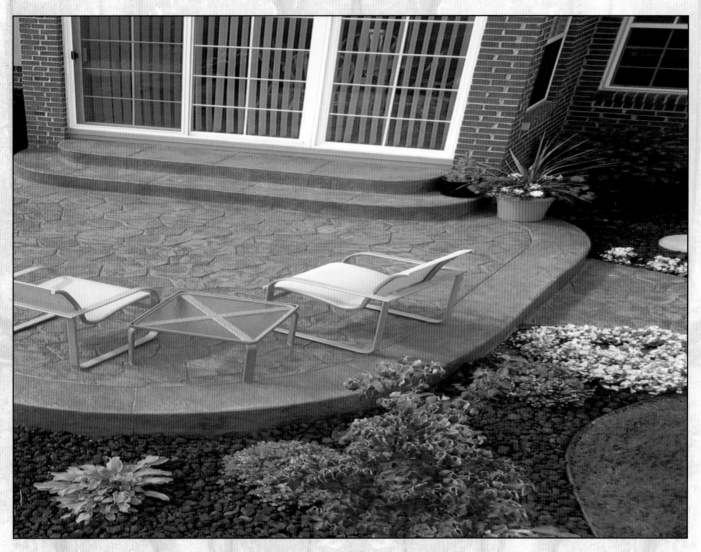

▲ An intimate patio is made even more pleasing with the texture and pattern of stone underfoot. *Courtesy of Courtesy of Action Concrete Services*

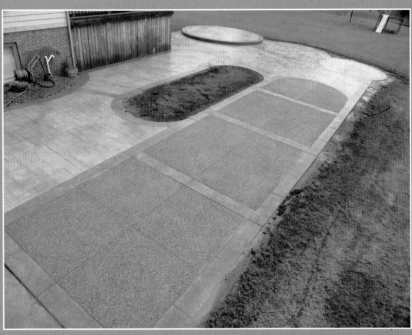

▶Exposed aggregate and smooth texture define spaces. *Courtesy of Courtesy of Action Concrete Services*

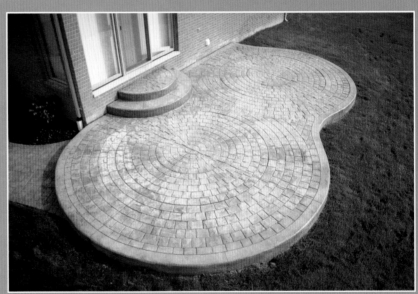

▶This cobblestone-patterned circular pad makes an ideal sitting area outside the sliding glass doors. *Courtesy of Courtesy of Action Concrete Services*

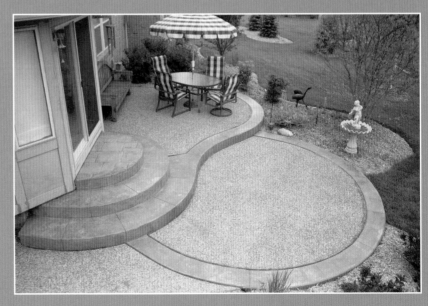

▶Two tones and textures, stamped concrete and exposed aggregate, deeply contrast and add interest to the entry steps and sitting area. *Courtesy of Courtesy of Action Concrete Services*

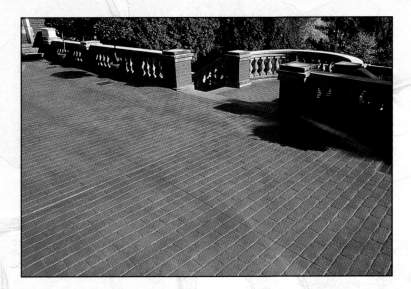

▲Concrete can be cast in a variety of different shapes and patterns, giving the look of bricks without having to go through the extensive labor of laying them. *Courtesy of Bomanite Corp.*

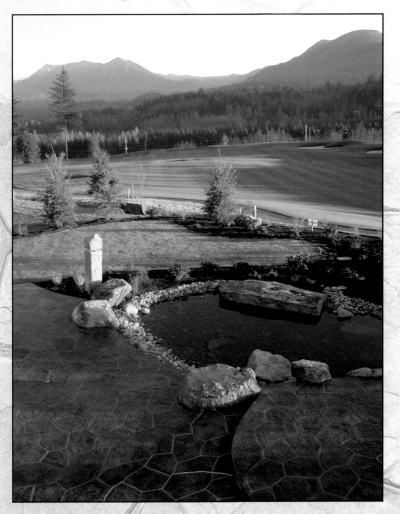

▲ A flagstone pattern gives a natural look, which complements an ornamental pond. *Courtesy of Bomanite Corp.*

Photography by Matthew Gregorchuk

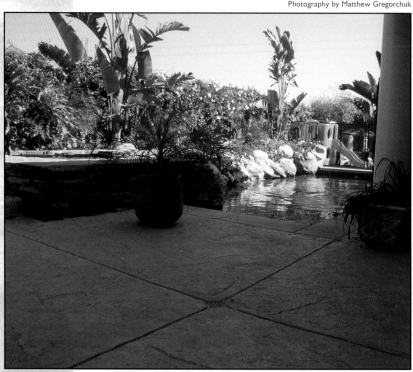

▶ Concrete that has been stamped and stained to look like slate adds to the overall "cool" feeling created by this deck and pond. *Courtesy of Concrete-FX*

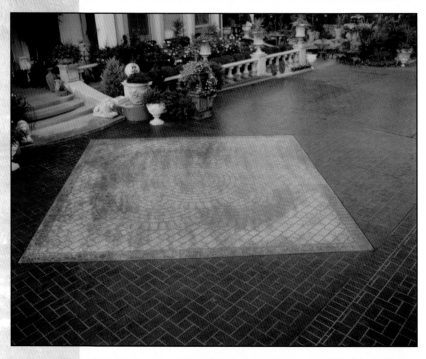

▶ A bright surprise in blue, a cloverleaf pattern stamped onto this large residential entryway, provides a playful element that incorporates a formal herringbone pattern. *Courtesy of DCI*

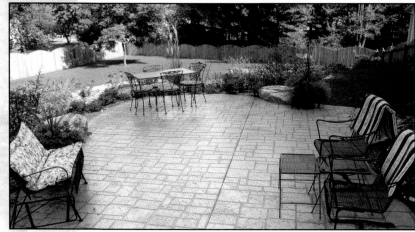

▶ A patio's warm brown tones and a natural curving border unify the hardscape with the lawn and plantings beyond. *Courtesy of DCI*

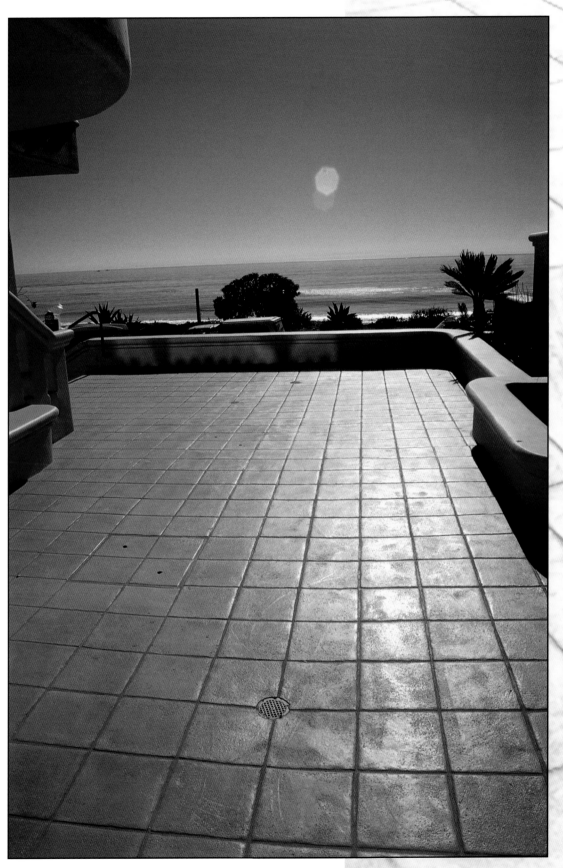

◄ An expanse of patio has been stamped, stained, and sealed to a shine that makes its surface a dead ringer for terra cotta tile. *Courtesy of Sullivan Concrete*

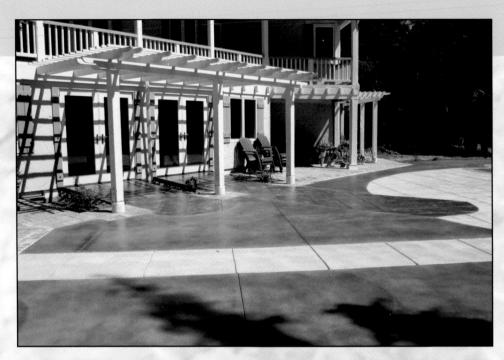

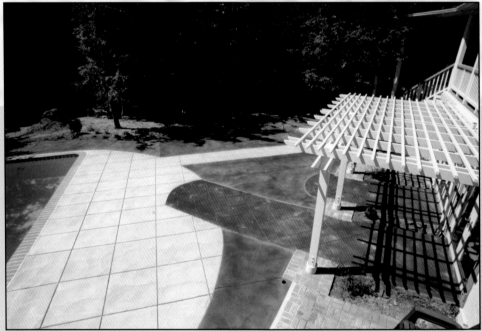

▲ Color zones were playfully established using concrete stains in this patio and pool deck. *Courtesy of The Concrete Colorist*

Before and after images show a patio's transformation to emulate bluestone slate. Homecrete Concrete Surfaces invented a special tool for this installation of an overlay. Besides costing about half of what real "bluestone slate" costs, the patio is free of the fragility of real slate because the water does not get into grout joints and cause problems during freeze/thaw cycles. *Courtesy of Homecrete Concrete Surfaces*

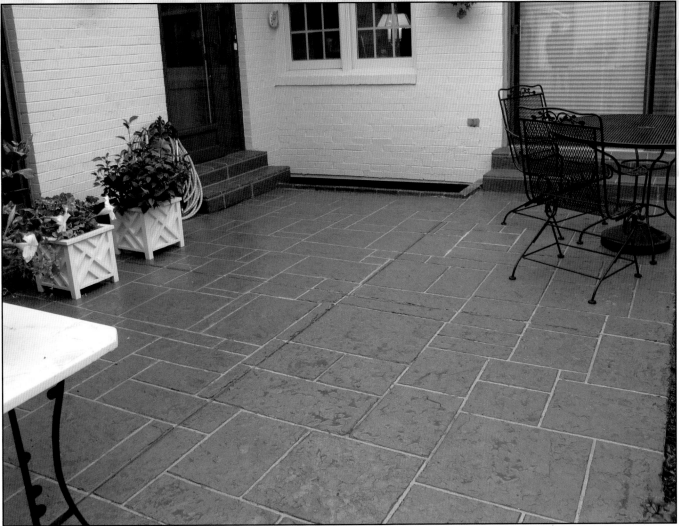

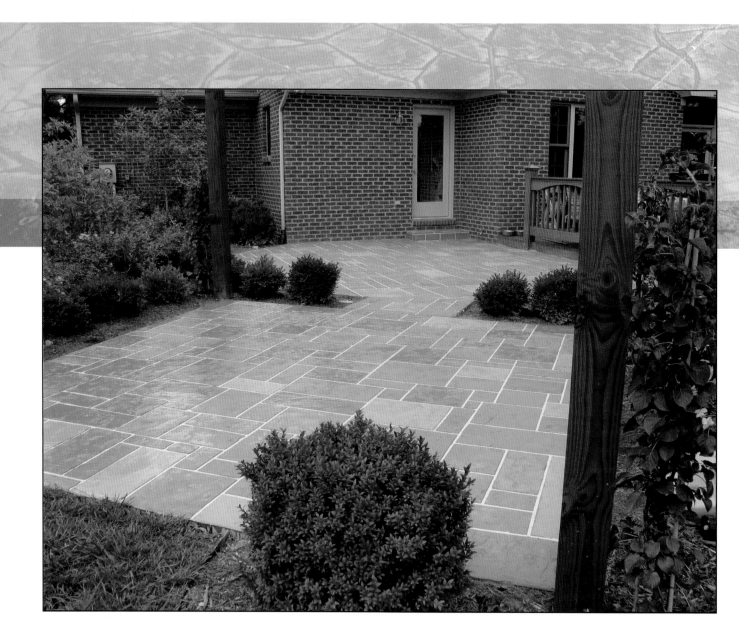

▲ An emulated bluestone patio was laid out in two zones that created transitional areas between the back door and the yard. *Courtesy of Homecrete Concrete Surfaces*

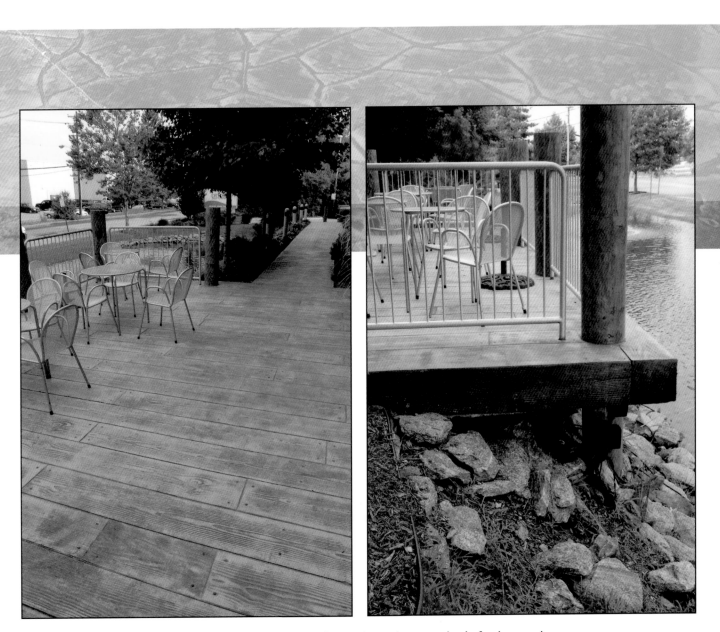

▲If the wood grain and natural weathered tones don't fool you, the effect of rusty nails will drive the point home. *Courtesy of Concrete Concepts Inc.*

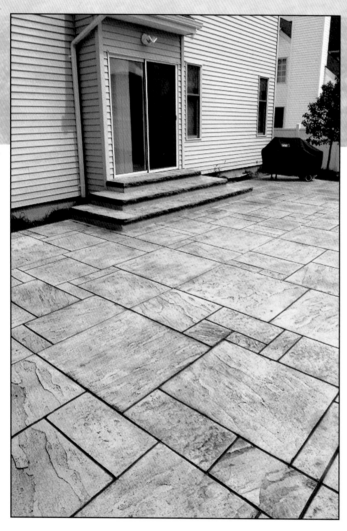

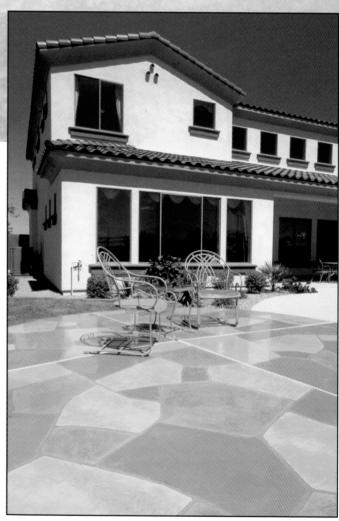

▲A patio takes on the hue and texture of real slate, at half the ticket price. *Courtesy of Concrete Concepts Inc.*

▲Flagstones in various shades of red and tan match this Southwestern style house. *Courtesy of XcelDeck™*

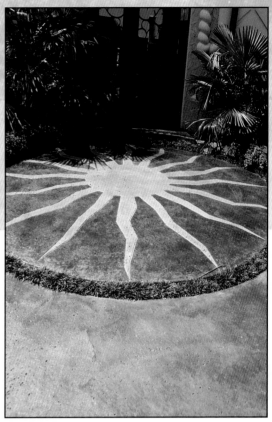

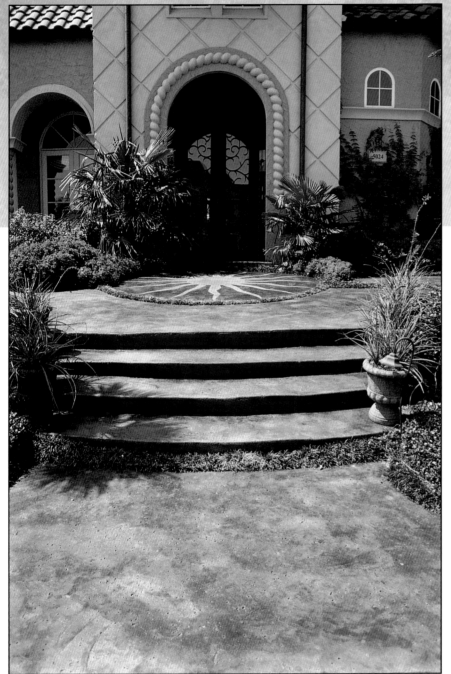

◀▲Staining gives the front steps of this home a rosy and warm welcoming feeling. A ring of grass around this section draws attention to the sun etched on the surface and further separates it from the rest of the surface. *Courtesy of Kemiko Concrete Stains*

Pool Decks

It used to be that if you had a pool, it consumed most of the backyard. Today the trend is shifting. The National Spa & Pool Institute (NSPI) says small pools are hugely popular. About half the pools built these days are on the small side. Why? For starters, many backyards today on newer lots are a bit space-challenged. Also, there's a changing shift in the purpose of today's pools.

People want to vacation in their own backyards, and pools are just part of the big picture. The NSPI reports that outdoor living spaces, made up of kitchens, furnished seating areas, fireplaces, and more, offer enjoyment throughout the year for residents in many parts of the country. The pool is just one part of an extended living area.

Pools are also becoming more specialized, with a strong focus on aesthetics, transforming the pool and backyard area into a mini-resort with lighting and sound, spas, waterfalls, fountains, and decorative decks.

In designing the deck, one of the most important considerations is what type of material to use. Location may play a great role in this deci-sion, as well as the amount of traffic the deck will bear. Deck areas surrounding a pool can run the gamut from poured-in-place concrete, broom finish concrete, exposed aggregate, tile, pavers, and stone masonry. Of course, all of these effects can be had in decorative concrete.

One of the finishing touches of the pool and pool deck is the coping. The coping is the material that caps the pool shell wall. Material options include poured-in-place, precise concrete material, tile, and natural stone. Poured concrete allows the coping to be one unit with the pool deck, incorporating the coping right over the edge of the pool so there is no break in the finish on the horizontal plane. This method can help to make a small area around the pool look much bigger, and give the deck cleaner lines.

▶A concrete deck was stained to match the home beyond, creating a unified architectural statement. *Courtesy of The Concrete Colorist*

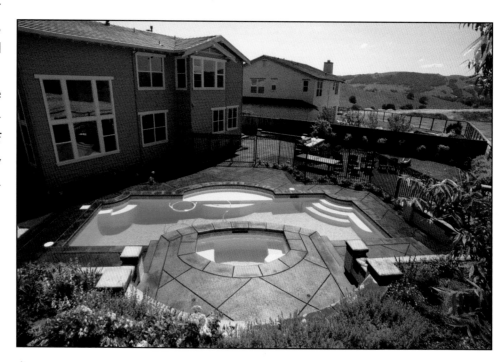

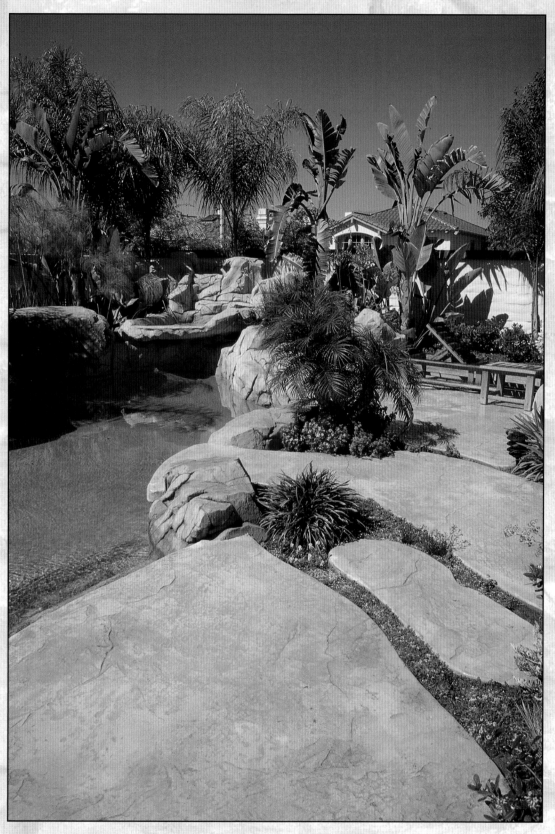

▲ Around this pool, concrete was cast in the shape of large textured stones for a "natural" look. *Courtesy of Sullivan Concrete*

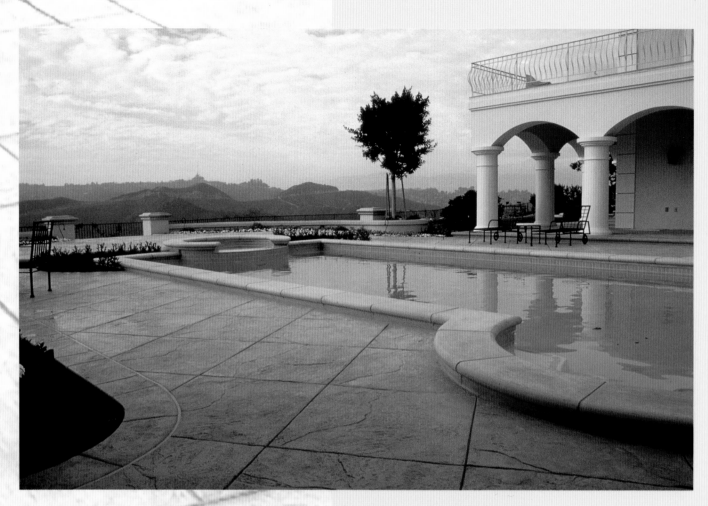

Square stones and carved coping create a Roman bath setting for a cool, blue pool. *Courtesy of Sullivan Concrete*

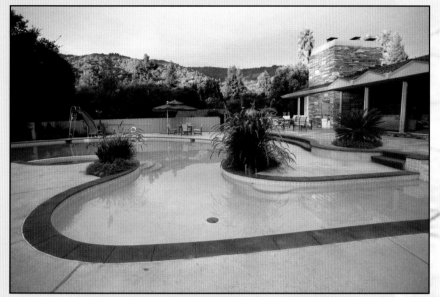

A dark skirt defines the edging on this free-form pool. The stained swath is more than decorative, it serves as a great safety feature. *Courtesy of The Concrete Colorist*

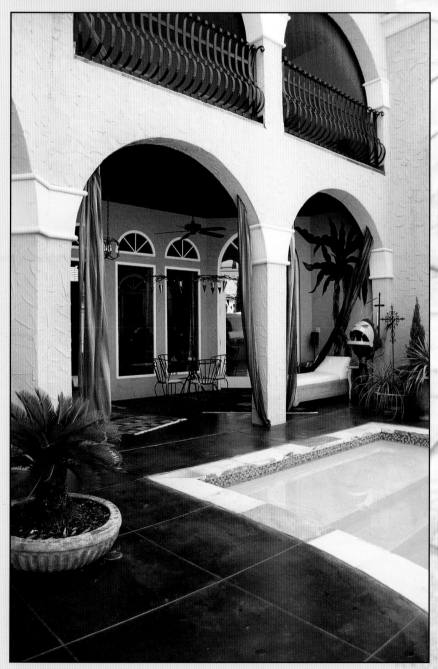

Resembling glazed slate, this pool deck and patio has been treated with a special black satin stain and then sealed for a luxurious sheen. The black stain actually produces black/brown undertones that mimic tortoiseshell. *Courtesy of Kemiko Concrete Stains*

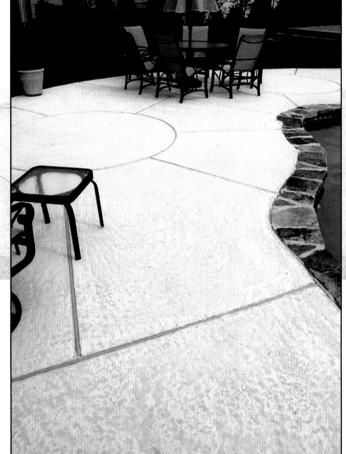

Faux stone lines the pool, skirted by concrete that has been gently stamped and stained for texture and warmth of tone. *Courtesy of Concrete Concepts Inc.*

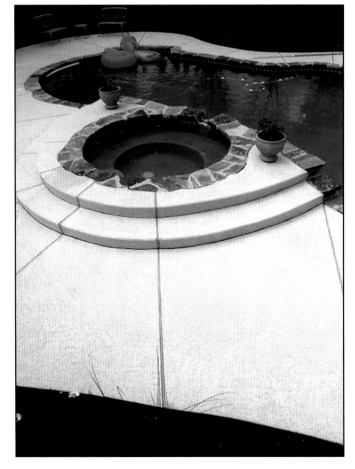

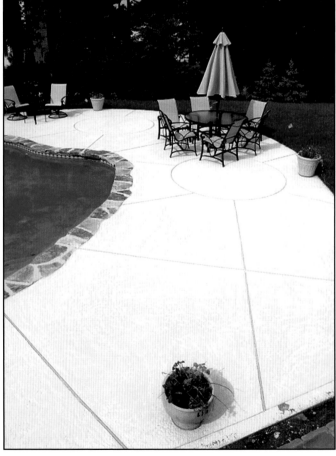

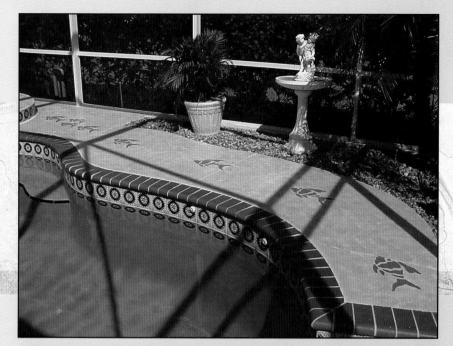

Tropical fish etched in a pool skirt further enhance a nautical theme. *Courtesy of Engrave-A-Crete™*

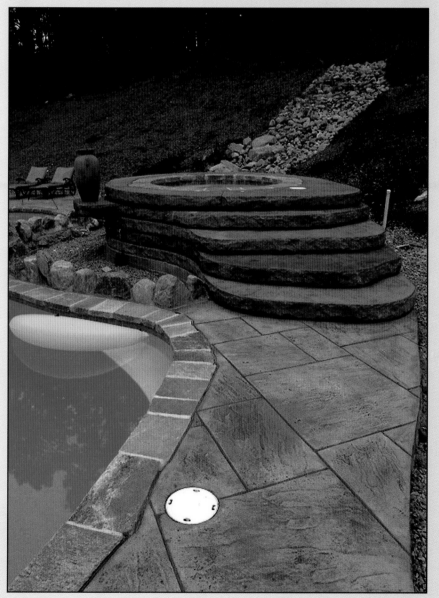

A spa crowns concrete steps carefully molded and stained to imitate stone. *Courtesy of Concrete Concepts Inc.*

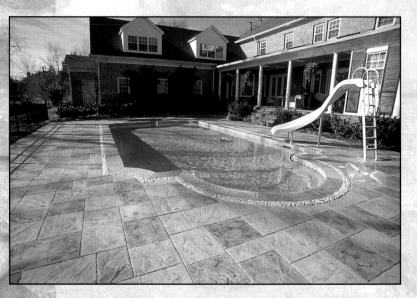

Square stone effect was created for this concrete pier and pool deck. The same pattern was carried into the lowered lip up the pool, over which an automatic pool cover slides. *Courtesy of Concrete Concepts Inc.*

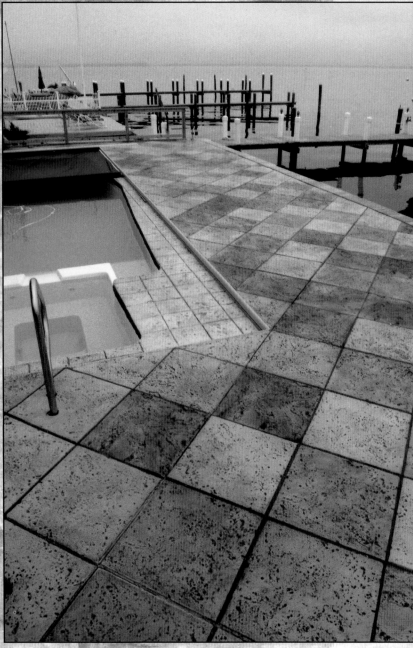

A river-stone border around the coping adds decoration to the pool deck, and acts as a safety measure by drawing attention to the edge of the pool. *Courtesy of Bomanite Corp.*

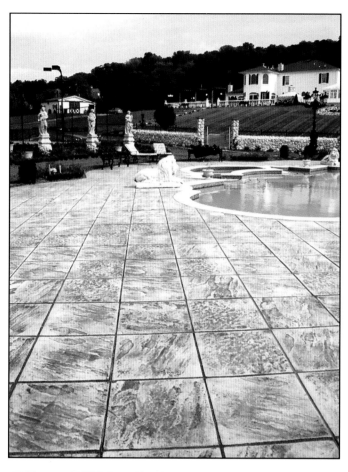

An expanse of faux slate encircles the pool, admired by marble statuary. *Courtesy of Concrete Concepts Inc.*

An embankment artfully ascends to a raised patio via concrete slabs disguised as stacked stones. *Courtesy of Concrete Concepts Inc.*

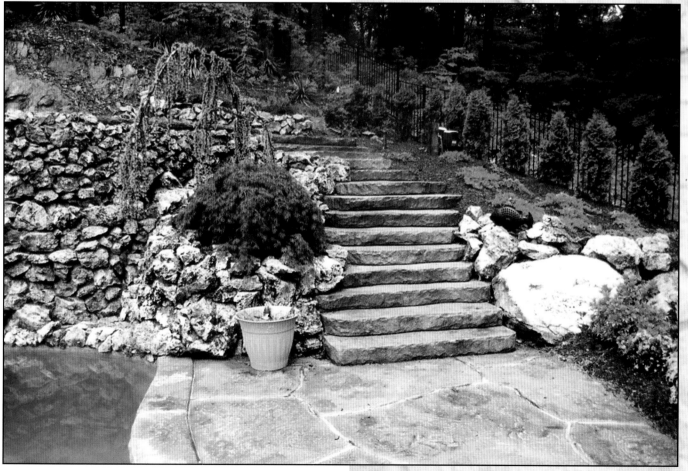

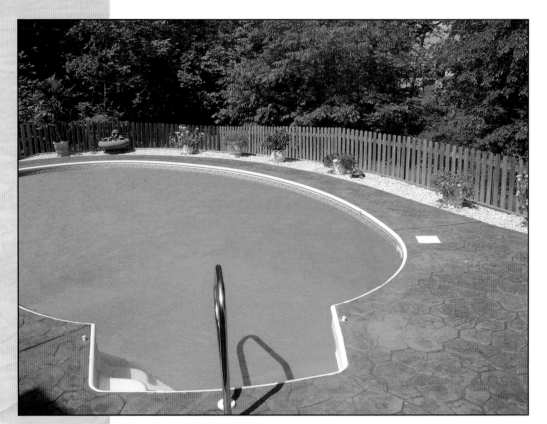

This pool deck provides easy care and elegance. The pattern and textures unify the entire pool area, providing slip-resistant footing, and long lasting beauty. *Courtesy of BonTool Co.*

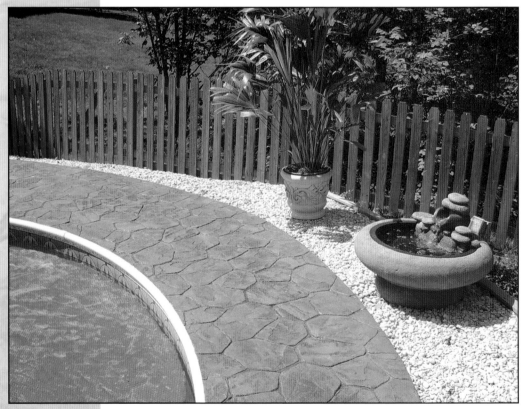

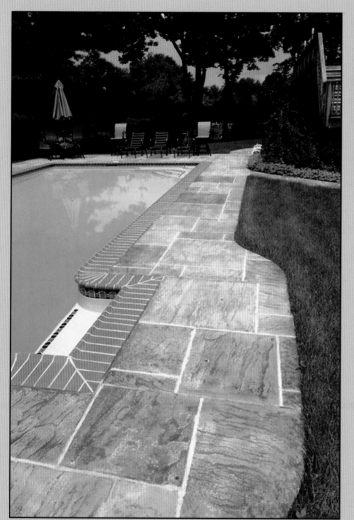
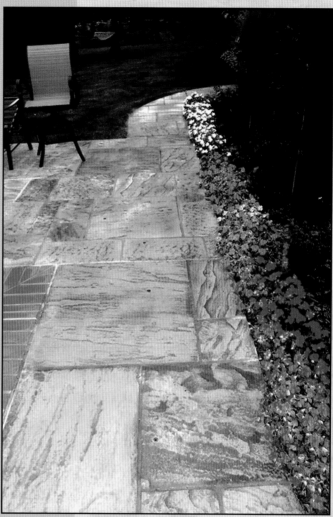

Variations in color fool the eye and foot in this concrete pool skirt and walk. Even the coping, seemingly brick, is fashioned from sand and cement. *Courtesy of Concrete Concepts Inc.*

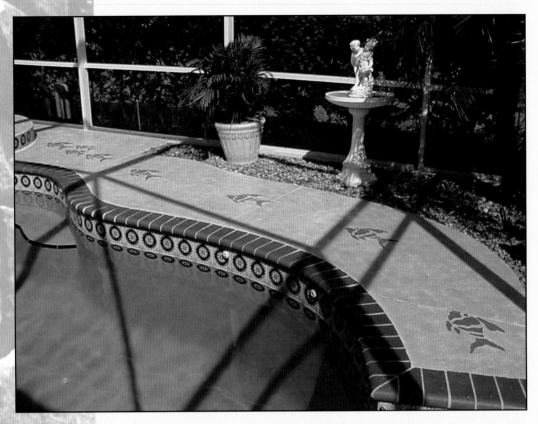

Tropical fish etched in a pool skirt further enhance a nautical theme.
Courtesy of Engrave-A-Crete™

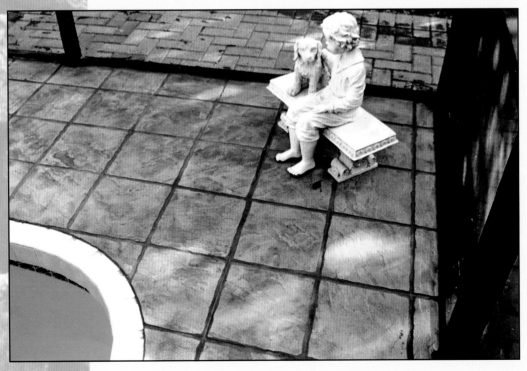

Square stamped concrete tiles frame an indoor swimming pool.
Courtesy of Yoder & Sons LLC.

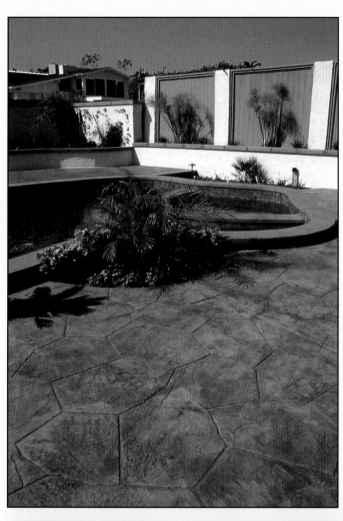

◀Variable surface textures and tones aid in the illusion that this is a natural stone patio. *Courtesy of Sullivan Concrete*

▼A grid-pattern is perfect complement to the random shape of a pool. A light stain dresses up the concrete. *Courtesy of Sullivan Concrete*

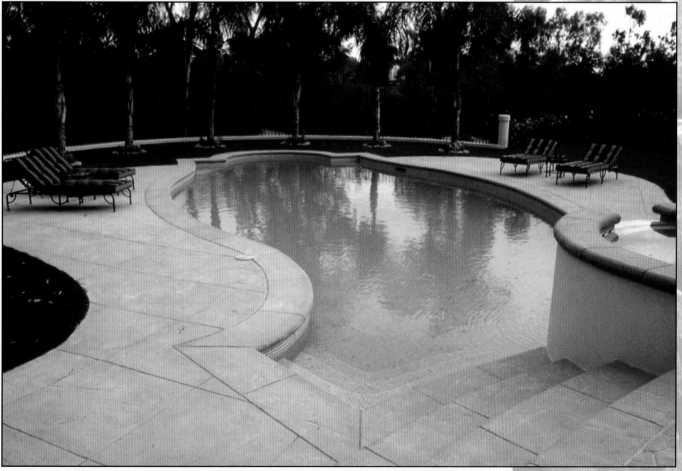

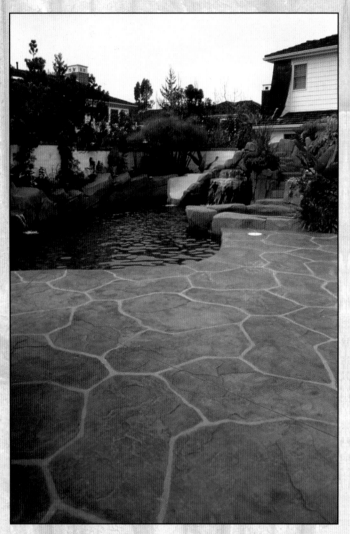

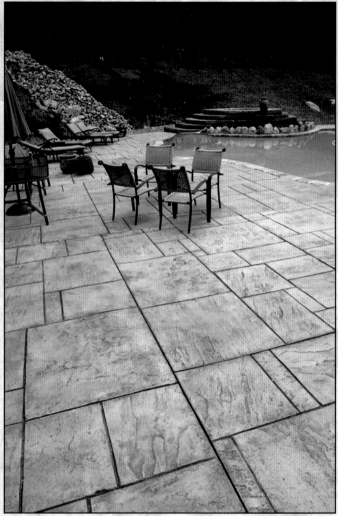

▲A random stone pattern appears to be mortared in place, with seams left in the natural color of concrete. *Courtesy of Sullivan Concrete*

▲A random flagstone pattern has been textured and dyed to give the effect of sandstone around this backyard pool. *Courtesy of Concrete Concepts Inc.*

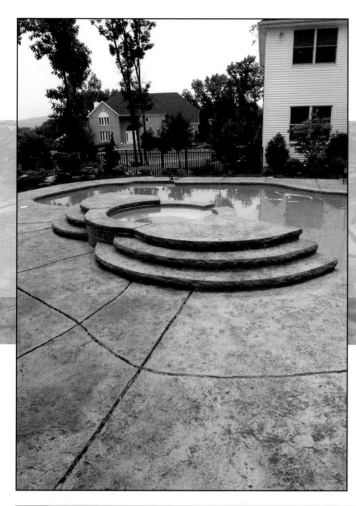

Mottled tints and textures unify the skirting of pool and spa. *Courtesy of Concrete Concepts Inc.*

▼Textured coping around the pool presents the realistic feel of cut stone. *Courtesy of Concrete Concepts Inc.*

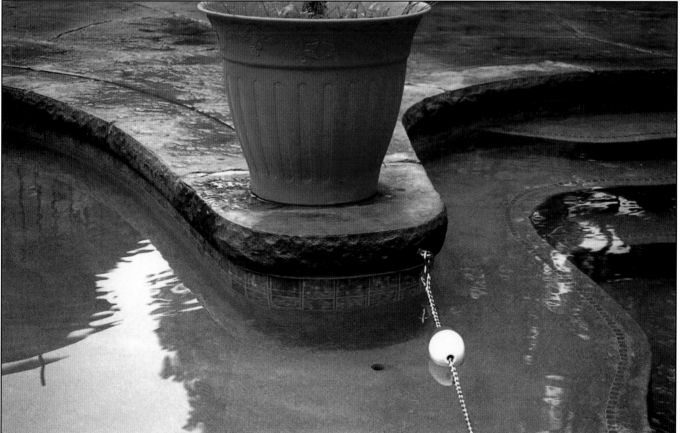

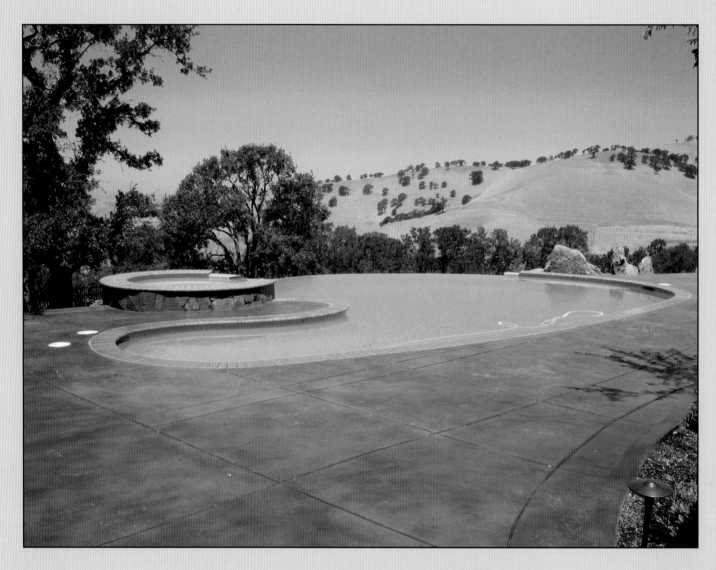

▲Mottled tones on the pool deck are in keeping with the brown California hillside beyond. *Courtesy of The Concrete Colorist*

Outdoor Rooms

Americans are remodeling and renovating at a cost of more than twice the amount being spent for new construction. In many cases, home improvements pay off with a financial return on our investment, not to mention the enjoyment and use we derive from the improvements.

One of the rooms receiving the most attention these days is the backyard. In fact, the Hearth, Patio, and Barbecue Association (HPBA) says we'll spend $65 billion this year on outdoor hearth products, grills, furniture, lighting, upgraded landscaping, and gardening amenities, pools, spas, and hot tubs.

The backyard patio is the new room to relax, entertain, play, and eat in. The HPBA says that some 91 percent of pool and spa stores now require a kitchen/dining component with their new installations. Outdoor grilling is growing more sophisticated, and more popular than ever. In fact, some 81 percent of families report owning a grill.

"Backyard living is, in a word, huge," reports the HPBA. "Nesting has given way to cocooning, which has morphed into living and connecting…The North American homeowner is spending more time at home and within the community with family, friends, and neighbors."

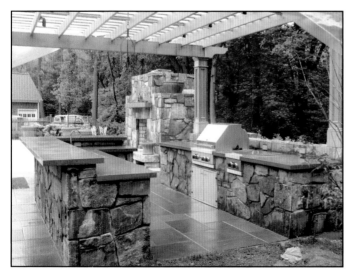

▲ For a family that likes to barbeque, here's an entire outdoor kitchen fashioned from concrete. *Courtesy of The Concrete Impressionist.*

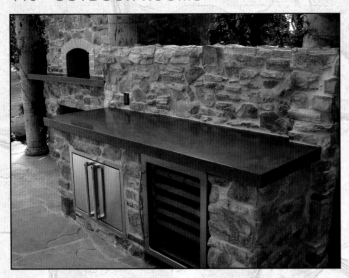

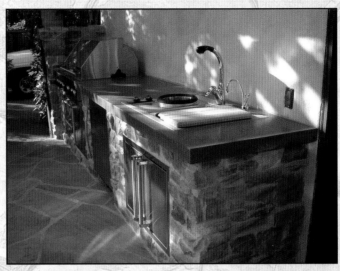

▲▶ This patio is designed for the family who likes to eat outdoors. It features a barbeque grill, a brick oven, a refrigerator to keep food cold, plenty of counter space for preparing meals, a slatted roof to keep the sun off of the diners, and a fire pit perfect for roasting marshmallows or for sitting around after a meal eaten al fresco. *Courtesy of Xtreme Concrete*

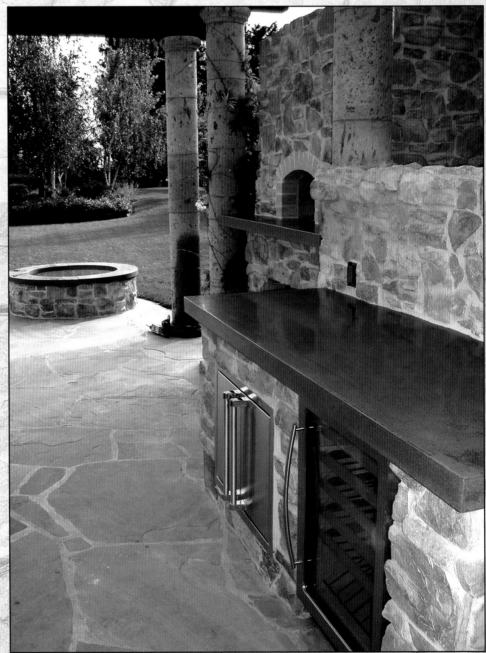

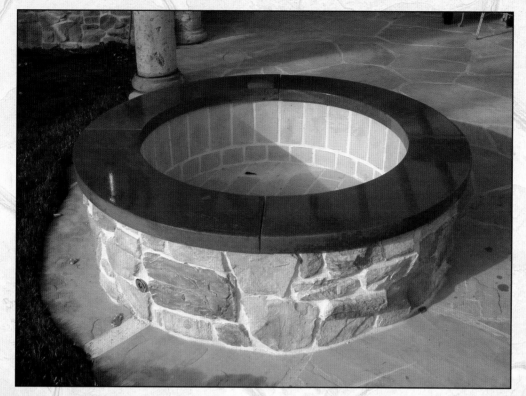

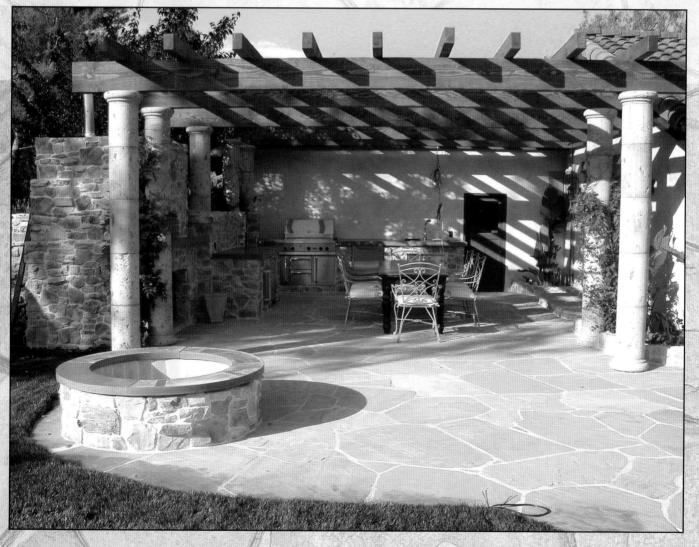

A concrete countertop mimics the look of worn stone. Worn looks are accomplished through staining and applying molds to texture the setting cement. *Courtesy of Bomanite Corp.*

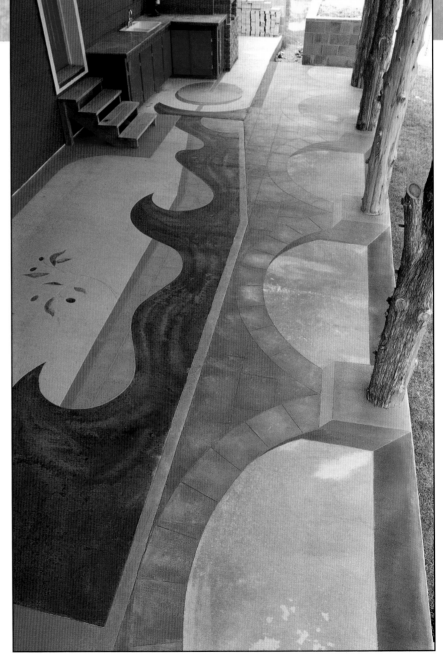

The floor of this covered outdoor living area has been given a unique treatment with decorative concrete staining. The vibrant colors and three dimensionality of the design evoke a Tuscan landscape, and make this a one-of-a-kind work of art that neighbors will be talking about for a long time to come. Steven Ochs, a professor of art at Southern Arkansas University, worked with the homeowners and craftsman Gerald Taylor to create a plan for this eye-popping patio/porch. He created scale drawings directly on the concrete using charcoal. Then Taylor did the engraving using an angle grinder and turbo blade, ready for the bright transformation of water-based stains. A solvent acrylic finish, refreshed annually, protects the surface from daily wear and tear. *Courtesy of Images in Concrete*

(Continued on the following 2 pages)

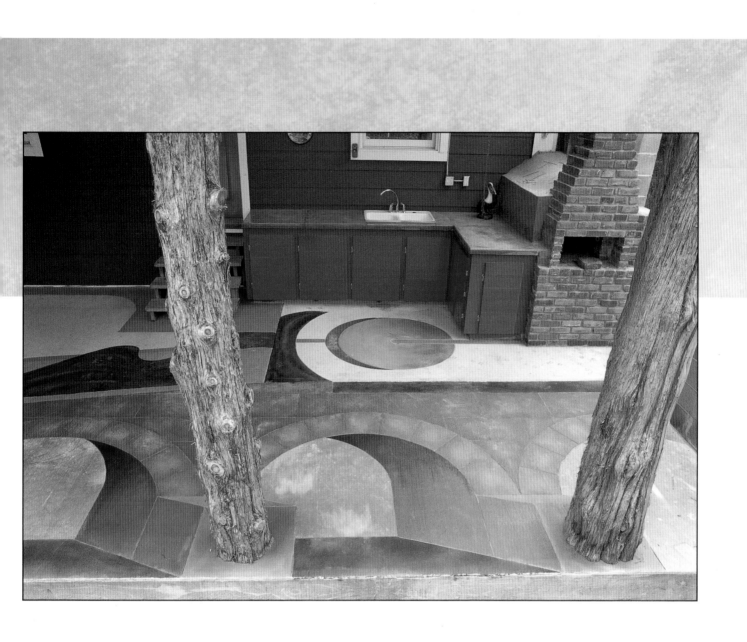

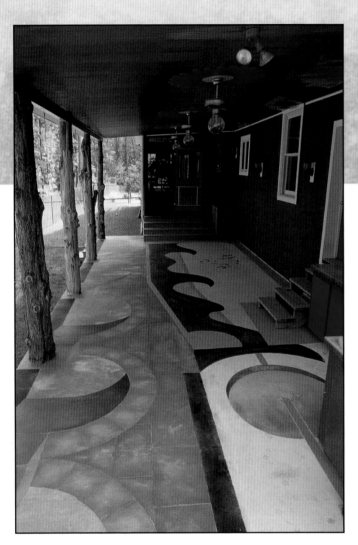

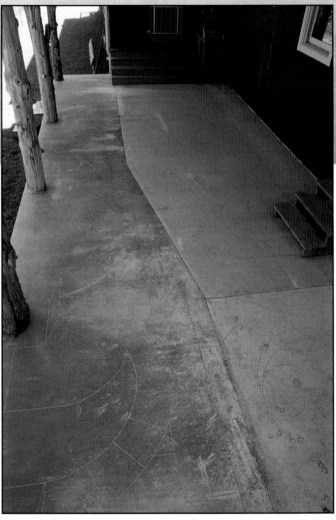

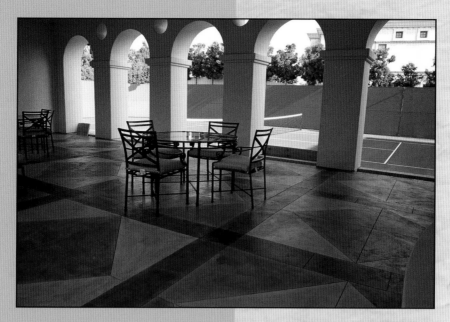

Parquet flooring in colored concrete creates a memorable surface in this sheltered outdoor entertainment area. *Courtesy of Sullivan Concrete*

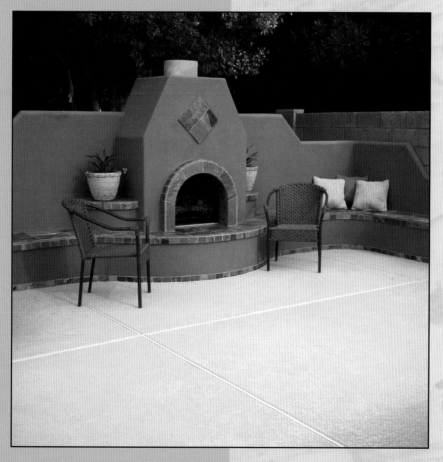

A concrete outdoor fireplace is a perfect way to warm up a chill autumn night. *Courtesy of XcelDeck*™

A ring of concrete makes a bench around a fire pit. *Courtesy of Ministry Concrete.*

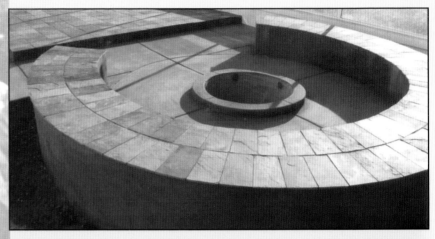

Concrete colors can be treated to make the patio match the house. *Courtesy of XcelDeck™*

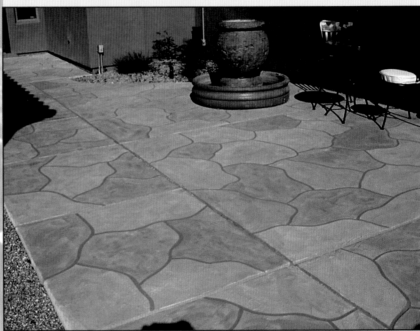

Faux tiling defines a small sitting area poolside. *Courtesy of XcelDeck™*

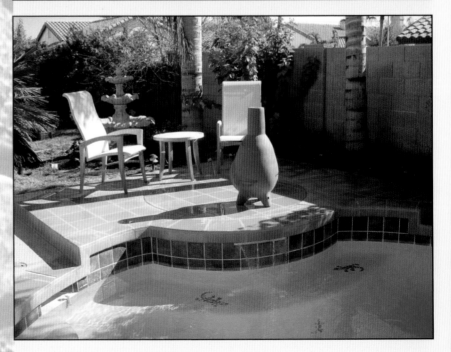

Glossary of Terms

bands. Bands can be any type of decorative concrete: stamped, exposed aggregate, colored concrete, or salt finish, to name a few. Bands can be 6"-24" wide, and are proportioned and spaced to complement the structure that the flatwork is in front of. Bands look best when contrasted against a different "field" decorative concrete. For example, the rock in an exposed aggregate mix placed in bands can be stunning next to colored concrete fields.

broom finishes. Bristles are used to create a "light broom" or "coarse broom." This is not a fancy finish but provides a non-slip surface.

colored concrete. Various manufacturers make colors that can be placed "integral" to the mix or "Dry Shake" which is dusted on.

engraving. An existing concrete pad can be dressed up using concrete engraving. After cleaning, repairing, and prepping the surface, acid stains are applied to color the concrete. The concrete is then engraved or routed in a pattern, removing the color from areas to create a design. The surface is then cleaned and sealed.

exposed aggregate. Colorful rocks are embedded in the concrete. When the top layer of cement paste is washed off – either chemically, with water pressure, or sandblasted – the rocks show through.

fields. Each section of flatwork is considered a field. These fields can all have the same decorative flatwork finish, be placed between bands, or be different in an alternating pattern.

float and trowel textures. Patterns can be made on the concrete, such as swirls, or different size arcs. The texture created can be coarse, medium, or smooth depending on the tool used to impart the pattern. Wood floats create coarser textures. Aluminum floats or steel trowels create medium or smooth finishes.

overlays. Products exist that can be applied to existing concrete in layers as thin as 1/8" thick. This can be stenciled on, or stamped after application, and treated with color hardeners and acid stains for decorative texture and appearance.

painting concrete. Concrete that is well cured can be painted for colorful effects. Painting concrete is almost always done to existing concrete, after a repair for example, whereas colored concrete is done with freshly placed concrete and specifically for decorative purposes.

patterned concrete. See stamped concrete.

rock salt finish. Water softener salt crystals 1/8" to 3/8" in size can be broadcast onto the fresh concrete. A roller is then used to press the salt crystals into the concrete. The surface is later washed, dissolving the salt and leaving small holes.

sawcutting. A power concrete saw can cut patterns into the concrete as soon as the concrete has hardened.

scoring. Decorative lines can be placed in concrete with "groovers." Groovers come in various depths and widths. For decorative work, the groover must penetrate the concrete at least 1/4". If the groove is also serving as a control joint, the groove must be 25 percent the depth of the slab.

stained concrete. Existing concrete can be dressed up by sawcutting patterns into the concrete and then staining different sections with concrete stains. Artisans can create variegated looks by blending stain colors on top each other.

stamped concrete. Concrete can be stamped to look like brick, cobblestone, slate, and a wide variety of other patterns. When combined with colored concrete the results can be fabulous.

toppings. Decorative flatwork can be produced with epoxy or other type thin coating over existing concrete. Surface preparation and getting a good bond is critical in this procedure.

travertine finishes. Often called Keystone. The concrete has a knock down finish with a smooth surface at its highest points, but rough in the low area. This is often used in hotter climates on pool decks and other surfaces desired to be cooler to the feet.

Resources

The following represent installers as well as product manufacturers for the projects pictured in this book:

Accu Flow Floors
Barrington, Illinois
847-304-9523
www.cnct.com

Action Concrete Services
Canton, Michigan
734-397-9200
www.actionconcreteservices.com

Advanced Surfacing
Austin, Texas
800-641-4947

ARENDS Construction
San Carlos, California
650-593-5313
www.trexpert.com

Artscapes
Albuquerque, New Mexico
505-452-2500
www.artscapesconcrete.com

BonTool Co.
Gibsonia, Pennsylvania
724-443-7090
www.bontool.com

Bomanite Corp.
Madera, California
599-673-2411
www.bomanite.com

Buddy Rhodes Studio, Inc.
San Francisco, California
415-641-8070
www.buddyrhodes.com

Classic Concrete
Richfield, Minnesota
612-243-0573
www.classic-concrete.com

Classic Concrete Design
Durham, North Carolina
919-272-2072
www.ccd-nc.com

The Concrete Colorist
Benicia, California
510-913-1991
www.theconcretecolorist.com

Concrete Concepts Inc.
Hackensack, New Jersey
201-488-2968
www.concreteconcepts.com

Concrete Creations
Tulsa, Oklahoma
918-812-8829/405-912-2311
www.acidstainedconcrete.com

The Concrete Impressionist
Brooklyn, New York
718-677-1298
www.concreteimpressionist.com

Concrete Tops of Winter Park, LLC
Winter Park, Florida
407-677-7373
www.concretetops.com

Concrete-FX
Agoura Hills, California
818-865-1198
www.concretefx.net

Creative Concrete Staining & Scoring, LLC
Hazel Green, Alabama
888-397-9706
www.concretefloorart.com

DCI
Webb City, Missouri
866-332-7383
www.decrete.com

DeWulf Concrete
Los Angeles, California
310-558-8325
www.dwconcrete.com

Engrave-A-Crete™
Bradenton, Florida
800-884-2114
www.engrave-a-crete.com

Flex-c-Ment; Yoder & Sons LLC
Greer South Carolina
864-877-3111
www.flex-c-ment.com

FormWorks
Raleigh, North Carolina
919-656-2598
www.concretecountertops.biz

Homecrete Concrete Surfaces
Lexington, Kentucky
859-621-7897
www.homecretellc.com

Images in Concrete
El Dorado, Arizona
870-862-5633
www.imagesinconcrete.com

J. Aaron Cast Stone
Atlanta, Georgia
404-454-3221
www.jaaroncaststone.com

Kemiko Concrete Stains
Leonard, Texas
903-587-3708
www.kemiko.com

Meld USA, Inc.; Extremeconcrete® Counters
Raleigh, North Carolina
919-790-1749
www.meldusa.com

Ministry Concrete
El Cajon, California
619-579-0347
www.ministryconcrete.com

Skookum Floors USA
Seattle, Washington
206-405-3700
www.skookum.com

Sonoma Cast Stone
Sonoma, California
888-807-4234
www.sonomastone.com

Specialty Concrete Designs
Poplarville, Mississippi
601-795-9249
www.specialtyconcretedesigns.com

Sullivan Concrete
Costa Mesa, California
714-556-7633
www.sullivanconcrete.com

The Ultimate Edge, Inc.
Rowlett, Texas
214-607-4004
www.ultimateedgeconcrete.com

Verlennich Masonry & Concrete
Staples, Minnesota
218-894-0074
www.stampedinstone.com

XcelDeck
Phoenix, Arizona
800-644-9131
www.xceldeck.com

Xtreme Concrete
Soquel, California
831-462-2334
www.xtremeconcrete.com

Built to Last: A Showcase of Concrete Homes. Tina Skinner. If you're thinking about building a new home, you'll want to start here. This introduction to insulating concrete form (ICF) construction will open your eyes to the future. ICF construction combines man's best building materials - concrete and steel, with high-tech insulation - bringing them together in simple forms a small child can lift. Anyone with basic carpentry experience can assemble them. Concrete construction offers rock-solid homes that can withstand hurricane-force winds, drastically cut energy costs, and provide unbeatable air and sound quality, in buildings as beautiful as the designer's imagination. Tour 15 gorgeous showcase homes, complete with floor plans, which demonstrate the endless design possibilities available with concrete. Architects, contractors, and homeowners share their experiences designing, building, and living in the best-built homes available today.

Size: 8 1/2" x 11"	226 color photos	144 pp.
ISBN: 0-7643-1617-6	hard cover	$29.95

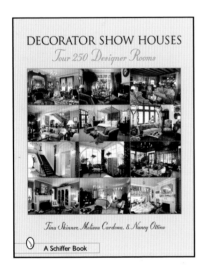

Decorator Show Houses: Tour 250 Designer Rooms. Tina Skinner, Melissa Cardona, & Nancy Ottino. Welcome to the Ultimate Decorator Event! For the price of admission to one show house and a modest luncheon, you'll get to tour 50 different show houses and over 250 spectacular rooms, where designers have pulled out all the stops to showcase their very best. Some of the most extraordinary work in interior design today is presented in 513 stunning color photographs. You'll see rooms saturated in glorious paint, windows dressed in the finest draperies, surfaces transformed with faux finishes, and furniture swathed in luxurious fabrics. Beginning the tour in foyers and hallways that leave lasting first impressions, you'll continue through glorious living rooms and family rooms that you'll never want to leave. Make your way through amazing libraries and home offices, dining rooms, kitchens, sunrooms, bedrooms, and bathrooms. You'll also get a chance to see innovative design ideas for media rooms, wine cellars, loft spaces, and bonus rooms. In this book you will find breathtaking and exciting designs that will inspire and amaze you, in addition to a list of extraordinary interior designers and annual show house events.

Size: 8 1/2" x 11"	512 color photos	224 pp.
ISBN: 0-7643-2051-3	hard cover	$44.95

Big Book of Kitchen Design Ideas. Tina Skinner. More than 300 big, full-color photographs of stunning kitchens provide an encyclopedic resource of design ideas for homeowners, designers, and contractors. The kitchen designs presented here include award winning designs and fancy product showcases designed for many of the nation's leading manufacturers of cabinetry, countertops, windows, appliances, and floors. Many styles of kitchens are covered, from contemporary and country, to classic European looks, early American, retro, and art deco designs. Special needs are addressed for elderly and handicapped users, as well as design issues faced by families with young children. There are designs for people who entertain frequently, and for those who need the kitchen to serve every purpose—from home office to dining room, to laundry room.

The book is designed as a reference library for the do-it-yourselfer, or as a bank of illustrations to share with a designer or contractor when seeking the right look for your old or new home. A reference guide at the back of the book lists manufacturers and designers ready and eager to help you on your way to creating the perfect heart for your home.

Size: 8 1/2" x 11"	321 color photos	144 pp.
ISBN: 0-7643-0672-3	soft cover	$24.95

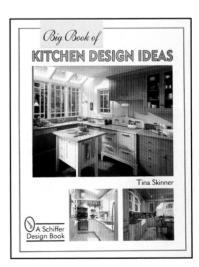

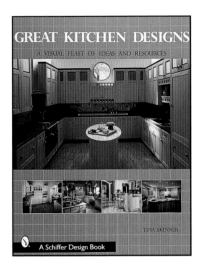

Great Kitchen Designs: A Visual Feast of Ideas and Resources. Tina Skinner. Here is a collection of 370 gorgeous color photos to pour over and ponder: images to inspire dreams. Full-color pictures of hundreds of beautiful kitchens will help you sort out the details and create your own unique cooking/dining/entertaining environment. All the elements of beautiful kitchens—flooring, cabinetry, windows, walls, lighting, appliances, surrounds, backsplashes and more—are pictured and discussed. Individual chapters will help you find the right look, exploring current trends from exotic to country, formal to feminine, antique to modern. Imaginative solutions for showing off collections are explored, as well as ways to open up the kitchen to wonderful outside views. There are lots of ideas for creating gathering places for family and guests alike into the hearth of the home. A special chapter on the small kitchen illustrates solutions for homes with limited space, and a resource guide at the back of the book will point you toward award-winning designers and top-notch manufacturers. This is an invaluable resource for anyone planning to remodel an old kitchen or build a new one and a great reference book and sales tool for any kitchen design professional.

| Size: 8 1/2" x 11" | 370 color photos | 176 pp. |
| ISBN: 0-7643-1211-1 | soft cover | $29.95 |

Fire Spaces: Design Inspirations for Fireplaces and Stoves. Tina Skinner. Warning: This book will make you want to include a fireplace or stove in almost every room in your home, and the yard too! The beauty, alluring warmth, and technological ease and cleanliness of today's hearth products make having a fire faster, easier, safer, and more enticing than ever. This book illustrates the allure, with more than 400 gorgeous color images. It's easy to find your style, visiting hundreds of homes and experiencing the way that they have incorporated fire spaces into their living spaces.
There has never been a book like this, with so many wonderful images of fireplaces and stoves. Most are shown within room settings, helping you to envision a fireplace as part of your overall decor. Plus, there's an enormous gallery of close-up images showing fireplace and stove details. You'll have trouble choosing just one!

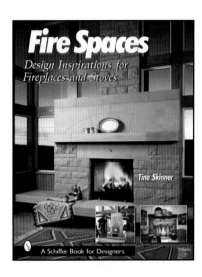

| Size: 8 1/2" x 11" | 417 color photos | 176 pp. |
| ISBN: 0-7643-1694-X | hard cover | $34.95 |

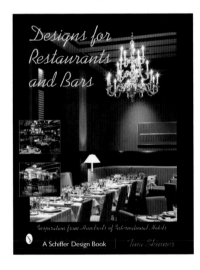

Designs for Restaurants & Bars: Inspiration from Hundreds of International Hotels. Tina Skinner. Here is a sumptuous banquet of the hospitality world's finest offerings in places to eat and drink. Tour more than 200 designer and boutique hotels from around the world, along with classics such as The Ritz in London, The Oriental Bangkok, the New York Palace Hotel, and the Hôtel Plaza Athénée in Paris. Top hotel and restaurant design firms from around the world are included, with industry leaders such as David Rockwell, Ian Schrager, Robert DiLeonardo, and Adam Tihany. Plus, there is work by design world icons Karl Lagerfeld, Pierre Court, Patrick Jouin, and Philippe Starck. The visual banquet includes classic European designs dripping in decorative molding and custom paneling, gold leaf and crystal chandeliers. There are starkly modern designs, fashionable Asian Fusion and eclectic settings, and tropical paradises, as well as playful and erotic designs. A resource guide provides contact information for design and architectural firms, as well as the beautiful establishments shown. This is an inspiring book for anyone planning or designing a place of hospitality and consumption.

| Size: 8 1/2" x 11" | 256 color photos | 176 pp. |
| ISBN: 0-7643-1752-0 | soft cover | $39.95 |

Schiffer books may be ordered from your local bookstore, or they may be ordered directly from the publisher by writing to:
Schiffer Publishing, Ltd.
4880 Lower Valley Rd
Atglen PA 19310
(610) 593-1777; Fax (610) 593-2002
E-mail: Info@schifferbooks.com

Please visit our web site catalog at *www.schifferbooks.com* or write for a free catalog. Please include $3.95 for shipping and handling for the first two books and $1.00 for each additional book. Free shipping for orders $100 or more.

Printed in China

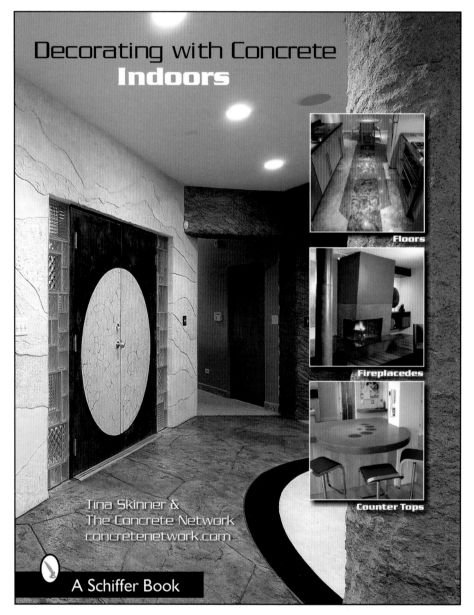